Minchinhampton
Memories

Stories told by a valued community

Maureen Reader

AMBERLEY

First published 2010

Amberley Publishing
Cirencester Road, Chalford,
Stroud, Gloucestershire, GL6 8PE

www.amberley-books.com

Copyright © Maureen Reader, 2010

The right of Maureen Reader to be identified as the
Author of this work has been asserted in accordance with the
Copyrights, Designs and Patents Act 1988.

British Library Cataloguing in Publication Data.
A catalogue record for this book is available from the British Library.

ISBN 978 1 84868 936 7

Typesetting and origination by Amberley Publishing
Printed in Great Britain

Contents

Foreword 5

Acknowledgements 7

Author's Note 11

Introducing Minchinhampton 13

Education 21

Leisure and Celebrations 35

'Incomers' 49

The Commons 59

Home Life, Health and Employment 69

The Church in Minchinhampton 79

Shop Talk 83

Transport and Travel 99

Food Access and Production 109

Energy and Fuel 117

Communications and Latest Technologies 125

A Future Sustainable Community 127

References 143

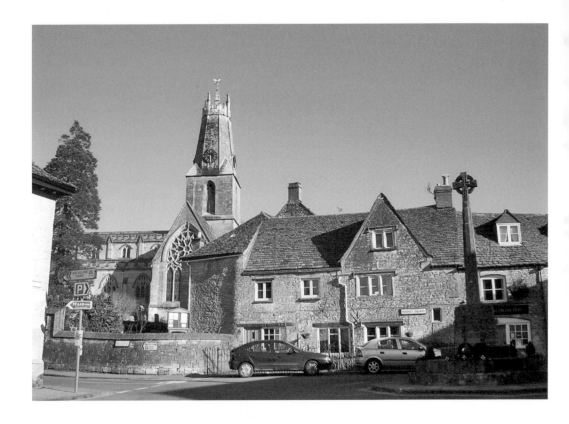

Our Valued Community

Minchinhampton is our little town,
Many voices with so much to say,
We may be Minch born or we may be Minch bred,
Or we may come from far far away.

And what do we offer to this jigsaw of ours,
This community up on the hill?
We may be a butcher, a teacher or wife
Or someone who'll prescribe a pill.

We're working together,
in all sorts of weather.
Good times and bad times, the same,
A supportive network of family and friends,

To lose this would be a great shame.

...by Maureen Reader, 2010

Foreword

When my oral history book, *Minchinhampton and Nailsworth Voices*, was published in 2001, it held a message for people. A quiet message. A simple message. And it was this: tell children about the world; about the dry plains of Africa that burst into colour with the rains of spring; about oceans so deep that no light can penetrate. Tell them about the wonders of the universe – supernova, black holes and dwarf stars. Teach them science, art, literature and music. But don't, whatever you do, forget to tell them about themselves. Stories about their grandparents and great grandparents who worked in noisy mills and down dark, dank mines; who drew their water from crystal-clear wells and washed in tin baths in front of blazing open fires. Stories about the past; about ordinary people and ordinary events which have helped shape us into what we are today.

One person above all took that enjoinder to heart: Maureen Reader. In fact, she did more than take it to heart. She ran with the idea and made it her own. For Maureen decided she wanted to write Minchinhampton's own biography. And with the help of a group of children from Minchinhampton School, she has succeeded brilliantly. The result is this book.

As if creating a beautiful patchwork quilt, Maureen and her team of helpers have sewn together memories, photographs, anecdotes and interviews with the town's present-day residents. And, thus, you'll find within its pages well-known and loved personalities such as John Bingle. You might know him nowadays as a knowledgeable, skilful gardener: but did you know that, as a child, he would play Tinayacky on the green slopes of Besbury banks? Or there's Mick Wright, the antique-dealing reverend who loves his motorbikes.

There are interviews with key figures like Janet Payne, who runs the Thursday-morning Country Markets in the Market House; and there's the cheese-maker Melissa Ravenhill, who talks about the difficulties of running a farm. Important events are marked, such as Michael Irving's retirement as rector in 2008. Local children get to tell their own tales: taking their dogs on holiday; going for cycle rides on the common. And it goes without saying that the area's most famous residents – the Minchinhampton Common cows – manage to get frequent mentions.

In short, this book is funny, thought-provoking, sad, evocative and fascinating. It is being launched as part of Holy Trinity's 750 festival, celebrating 750 years since the first rector was appointed. We know that the first of those clergy was a certain Roger de Salinges, appointed by the French nuns who once owned the land. But beyond that, there's little information. Was he kindly? Portly? Bearded? Did he love Minchinhampton? What did the settlement look like when he presided at the altar? Sadly, we just don't know. Perhaps residents in another 750 years will somewhere, somehow, have copies of books like this that will satisfy their curiosity about the intimate past.

Sometimes we can look at far horizons, dream of distant lands, and forget about the things that are under our noses; things we take for granted. Yet our homes, our lives, our memories, our community: these are the facets that make us who we are. And we should value them.

All the elements of this book are precious to me. I have known Maureen as a friend for many years; I am a governor of Minchinhampton School, which is privileged to educate happy, forward-thinking and vibrant pupils, some of whom have been involved in this project, and I have lived in or near Minchinhampton itself most of my life. I am very proud of all these connections.

And whether you're simply reading this book, or even included in it, I know you will put it down feeling equally proud to be connected to the ordinary, amazing, normal, surprising community of Minchinhampton.

Katie Jarvis, 2010

Acknowledgements

Firstly I would like to thank my family – John, Caroline, Andrew and Joanne, for their wonderful patience during the compilation of this book.

I would also like to express my gratitude to my sister, June, for her additions and amendments in the proofreading.

Many thanks to Katie Jarvis for her advice and encouragement throughout the project.

I'd also like to express my gratitude to Di Wall and Hilary Kemmett for kindly allowing me to use their photographs, and my colleagues on the Transition Minch team for their continued support.

And last but not least, my thanks must go to all of the following people of Minchinhampton. They have been very generous in sharing their memories, thoughts and feelings about Minchinhampton, as well as giving their time in allowing me an interview. This book would not have been possible without them:

Name	Born	Occupation
Poppy Cooke	1926	Retired Nurse
John Bingle	1945	Retired Plumber, Gardening Club
Michelle Thomasson	1959	Mature Student, Transition Minch steering group
Mark Robinson	1970s	Taylor's Butchers
Chris Stone	1960s	Architect and Managing Director of Quadra Bec
Melissa Ravenhill	1953	Dairy Farmer and Cheesemaker
Minchinhampton Bellringers, Angie Ayling and Colin Shellard	1940s and 1960s	Roofer, Headteacher, Engineer and others
Katie Jarvis	1960s	Author and Writer for Cotswold Life
Di Wall	1950s	Parish Clerk
Andrew Brooks	1952	Youth Leader Minchinhampton Youth Club
Time Detectives: Jack, Andrew, Dan, Flo, Hannah, Tabitha, Kara, Phoenix	1999 and 2000	Minchinhampton School Pupils in years 5 and 6

Peta Bunbury and Rees Mills	1967 and 1929	Information Assurance Consultant and Hereford Councillor
Henry Ravenhill	1985	Woefuldane Organic Dairy Shop Manager
Sophie Craddock	1960s	Cook and Owner of Sophie's Restaurant
Linda Nicholls		Business Regeneration Working Party, Art & Crafts, Parish Councillor
Pat Dyer and Sally Savage	1950s	Teaching Assistants at Minchinhampton School
Mick Wright	1950s	Owner of Trumpet Antiques
Fred Price	1950	M&B Stores
Rachel, Henry, Roger and Howard Auster		Attending university in Leeds and Bangor, 6th Form College and School
Ruth Morris	1960s	1st Minchinhampton Brownies, Owner of Stafford Cottage
Sue Edgley Future energy discussion		Chair of Transition Minch, Therapist and Healer
Youth club members	1996/96	Thomas Keble School Pupils
Sally Lewis	1970s	Coigne Playgroup Leader
Janet Payne	1950s	Minchinhampton Country Market
Lucy Offord	1965	Owner of Tobacconist Farm and Shop
Ian Crawley and Michael Sheldon	1950s	On the steering group of Transition Minch. Ian Crawley is a Parish Councillor and retired town planner.
Sue Smith		President of Minchinhampton WI and a retired librarian and Parish Councillor.

Just some of the interviewers ...

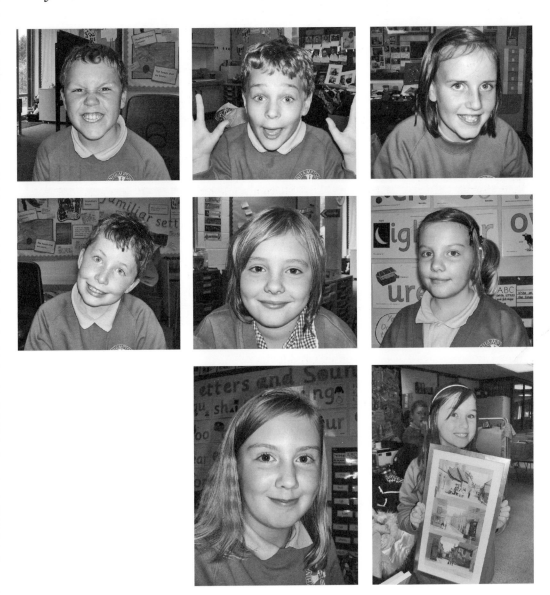

The 'Time Detectives' – (not in the order shown): Flo Pond, Daniel Rock, Hannah Mason, Kara Lowrie Plews, Andrew Reader, Jack Stubbs, Phoenix Lewis, Tabitha Windle-Hartshorn

Peta Bunbury & Rees Mills

Di Wall

Andrew Brooks

Poppy Cooke

Sophie Craddock

Janet Payne

John Bingle

Author's Note

In 2007 a DVD was produced for the parents of pupils at Minchinhampton School. It was a snapshot of typical life around the school – pupils working in the classrooms, younger ones outside doing role play in the outdoor classroom, and so on.

The DVD begins in assembly. I could see one of my own children there, as the camera slowly panned over the children as they sang. Many of the children I recognised; I have some knowledge of their families, which of them have grandparents here and those whose families have been in Minchinhampton for generations, and others whose families who have moved here much more recently.

As I watched the video, so many questions started to come to me:

Who are you, where are you from and has your family always lived in Minchinhampton?

What will you do with your life, and where will you eventually settle? What types of communities, and indeed cultures, will you become part of, and how will you contribute?

How has Minchinhampton touched your life and your way of thinking, and how do you feel that Minchinhampton has changed over the years – for better or for worse?

These are just some of the questions that you, the reader, will find answered in this book. But the overriding question of all must be: what is it that you value most about Minchinhampton?

From Scrapbook to Community Autobiography

When I set out to write this book I decided that I would like it to read rather like an autobiography, a tribute to the members of our community from the past, up to the present day, and also our thoughts for the future.

I also wanted scraps of information which would inform the reader and put things into context. However, as I delved deeper, I began to realise how much affection there is for this little town. I discovered the pledge that many people had signed to show how much they valued their community.

So many questions, and so many generations of children who have gone through a Minchinhampton childhood.

Even in the last century there were many changes with social reforms, increased rights for women, the huge changes brought about as a result of the two World Wars, and the many changes in personal freedom brought about by the advent of the motor car and cheap air travel. Last but not least, the explosion in easy communications made possible by mobile phones and the internet.

Now let us see what the residents of Minchinhampton have to say about life in our little Cotswold town.

Introducing Minchinhampton

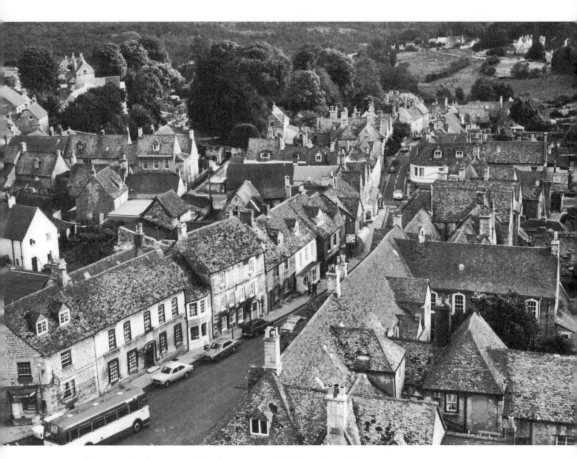

View from Minchinhampton Church Tower overlooking the High Street, 1947.

It all began with a campaign back in the winter of 2008 ...

The 'I Value Minch' campaign was the brainchild of Minchinhampton's Business Regeneration Working Party. It was set up in response to concerns from traders that business in the town was on the decline.

Locals were asked to pledge to spend at least £2 a week in Minchinhampton centre and in return they received an 'I Value Minch' wristband. The bands were

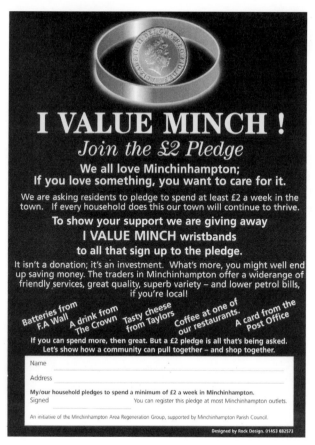

'I Value Minch' flyer·

given away so that people could show their support for the campaign and to others in the community.

Soon after this a new group calling itself Transition Minch was set up to raise awareness and to empower local people to work together and plan ways to deal with global warming and declining energy supplies.

Various new local initiatives took off in 2009, including local wood gathering around the slopes of Minchinhampton Common (in partnership with the National Trust), increased composting, energy saving and recycling workshops and also an after-school club in Minchinhampton School involving year 5 and 6 pupils.

A photographic competition also took place, asking residents to provide photographs around Minchinhampton from the 1960s and 70s. Hilary Kemmett was the lucky winner awarded with a gift box of selected cheeses from the new Woefuldane Organic Dairy Shop in Minchinhampton High Street.

These various initiatives, including a number of others around the town, culminated in the awarding of the Calor Village of the Year Award for the South West Region, at the end of that year.

This book has evolved from a community scrapbooking project carried out at Minchinhampton School in the Autumn of 2009

What it has become is a celebration of the place and its people, including interviews with key residents of Minchinhampton, as well as photographs, illustrations and a wealth of information piecing together the jigsaw of Minchinhampton's history from the 1930s onwards.

I'd like to give you a brief background on how and why my community scrapbook project came about in the first place.

I was first inspired to explore Minchinhampton's past when I stumbled across Miss Pinnell's book, *Village Heritage*, in our local charity shop. It was published in 1986 and compiled with the help of pupils of Sapperton School. They became '... interviewers and sleuths, aspiring archaeologists, geographers and social historians ...' The book followed the history of the village up to modern times, and it generated a huge amount of interest, especially as it coincided with Michael Wood's BBC Domesday survey.

With this in mind, I took this idea along to our new headmaster of Minchinhampton School, Nick Moss, and he was very keen for me to run an after-school club giving the pupils the same opportunity to survey Minchinhampton's history from the 1930s to the present day – and also looking to the future as well.

I am very aware that there is a perception in many sectors of our society that a sense of community is being lost, due to our increasingly mobile and individualised lives.

Katie Jarvis touched on it herself when, in 2001, she published the book, *Minchinhampton and Nailsworth Voices*, and appealed to parents to talk to their children about their own childhoods, to share a sense of history and to think about how life has changed over the years.

A lot of people don't see the last century as being relevant history, but I do; I see the huge social changes that have taken place even in a small town like Minchinhampton. It has been fascinating listening to local people talking about their memories of being 'incomers' in the town, for instance, and how a new vibrancy in the community was generated by raising money for a new youth club, drama club and sporting facilities, and also how the advent of the motor car changed life for everyone.

As well as carrying out interviews myself out in the community, I invited a wide range of people in to school, to talk to the children; an elderly lady came in to talk about her Minchinhampton childhood during the war years; our parish clerk, Di Wall, came in and talked about the history of our local shops; we went behind the scenes of Taylor's the Butchers and Sophie's Restaurant. One of our local architects, Chris Stone, talked to us about future energy for Minchinhampton, and there were many interesting Minchinhampton characters sharing their reminiscences.

The children became 'time detectives' and loved wearing their own ID badges, meeting interesting people, taking photographs, asking questions and controlling the voice recording equipment. They have also seen their photographs in the local *Stroud News & Journal*, as well as Tom Long's Post; they have had their work displayed in the Minchinhampton Goodwill evening and a display and folder was put up in their school reception to show their activities. They finished the project with two scrapbooking workshops in PaperArts in Thrupp.

A few questions to start with...

- What was Minchinhampton like just after the war in the 1940s and 50s, and in the decades after that?
- We know what it is like now in 2009 but what is it going to be like in the 2030s, and how can we plan for this?

Now, let's look at Minchinhampton. We will be looking in a fun, yet serious way, at the memories of those who live here, and also thinking about how our actions now will shape our future.

A few facts:

The interesting church has a truncated spire looking over the Market Square. There are old cloth mills in the valleys to the south of Minchinhampton, as well as many very interesting landmarks around the Commons, many of which are owned by the National Trust.

But we are more interested in what the people of Minchinhampton have to say about their town. So let us begin...

Well, I still see Minchinhampton as home

Henry: How do I rate Minchinhampton now that I've left for university? Well, I still see Minchinhampton as home. I do look forward to coming home to see my family, but I do have to drive out to see my friends. I don't actually need to at uni because I'm in halls of residence – this being my first year.

I do play for the cricket team in Minch, when I'm home during the summer. It is a nice cosy town to come back to. A lot of my friends from secondary school, well, I've moved on now and to be honest, I don't see them much now.

Rachel: I do miss home but it's so good to have new friends. I've always been quite independent anyway, but now I know that I have actually left and it's just nice to come back, if you know what I mean. I don't think I could be persuaded to settle here, though.

Henry: Well, if I still had no idea what I wanted to do after university then I wouldn't be repulsed by the idea of living with my parents for a few years. I think they are quite nice people.

I know I wouldn't have enough money to buy a place of my own straight away, but to live at home for a while, then try and set something up for myself; that would be fine.

Roger: I really do love Minchinhampton as a community, but I prefer the idea of moving away and having a chance to spread my wings a bit, and be my own person.

Rachel: The thing about Minchinhampton is that everybody seems to know everybody and everybody's business. It's sometimes a good thing but sometimes not. I have to say that the community spirit is very good. I mean, Brian 'Arkwright', the manager of the shop, during this snowy weather; he has been working tirelessly to ensure that the shop is fully stocked, so that everyone can get what they need. Brian and Fred are such brilliant characters. The Crown has also been staying open, even when they wouldn't normally be open. Rose Newberry lives above the pub anyway.

Roger: She's brilliant, Rose!

Rachel: Brian has been staying at the Crown during the snowy weather, so that he could get up in the morning and get the supplies in.

Roger: Yes, I mean if it hadn't been for all the shops making a special effort to stay open, well, without them a lot of people would be very stuck really, not being able to drive down the hill because of the deep snow.

Rachel, Henry, and Roger Auster, born 1989, 1990 and 1993

What do I love about Minchinhampton?

What do I particularly like about Minchinhampton? Well, the people are very friendly, it's my home really. I do love the fact that we're unique in that we have cows roaming freely everywhere around Minchinhampton, although they might nibble things they're not meant to nibble or leave messages everywhere. That's Minchinhampton, and if you don't like it then go somewhere else. They are there for a purpose, aren't they? They keep the grass shorter on the commons and I think if you move to an area like this then you have to expect a few inconveniences. It's the same with the way in which they will slow the traffic down, standing in the middle of the road during the summer months. They have just as much a right to be here and drivers have to respect that, and not complain about it.

I must say that most people do love the atmosphere that the cows bring to Minchinhampton and there is always great excitement when they are released out to pasture at the beginning of May each year.

Ruth Morris, born 1960s

It was such a relief coming back to Minchinhampton

How would I sum up Minchinhampton? Well, I don't think Minchinhampton will ever change – I hope not anyway. It is a lovely community with a great community spirit. You will always have an older element to the community because it caters so well for older people, and because of this, I don't think it will ever be allowed to become taken over or modernised in such a way that it would lose its character and charm.

My partner, Martin, his parents live in Butt Street so he knew Minchinhampton as a kid. We both lived away from this area for a number of years, then we met and we came back.

Having been away, it has really made me appreciate Minchinhampton even more. When we came back from France, this was simply where I wanted to be. We were living out in the country over there, completely in the middle of nowhere, surrounded by farmland. It was such a relief coming back. It is not easy working over there. You think you speak good French when you go on holiday, but when you have to buy a house, open a bank account, run a business, you can feel very cut off. And also, the French are very insular in their little communities; I mean one house with a whole family of three or four generations in it, which is lovely in a way, but it meant that we didn't feel very welcome there.

Sally Lewis, born 1970s

A relaxed and welcoming atmosphere

Having absorbed so many newcomers, especially in the last fifty or so years, Minchinhampton has become a place that is recognised for being welcoming to outsiders. The people here may appear a little reticent at first, but try walking down the High Street, at any time of day, and you'll be surprised by the number of people that will take the time to engage eye contact with you, say 'Hello' and perhaps even start a friendly conversation.

What do I value most about Minchinhampton?

'The beautiful village square/High Street puts a spring in my step every time I walk through it.'

Ian Crawley

'The thing I most value about Minchinhampton is the friendliness.'

Michelle Thomasson

'The thing I most value about Minch is the quality of life here.'

Linda Nicholls

'Minchinhampton: grazing cattle; wild orchids; vibrant church; thriving school; interesting shops; caring people.'

Katie Jarvis

'It's the old adage for me, having grown up here ... "You can take the girl out of Minchinhampton, but you can't take Minchinhampton out of the girl!!"'

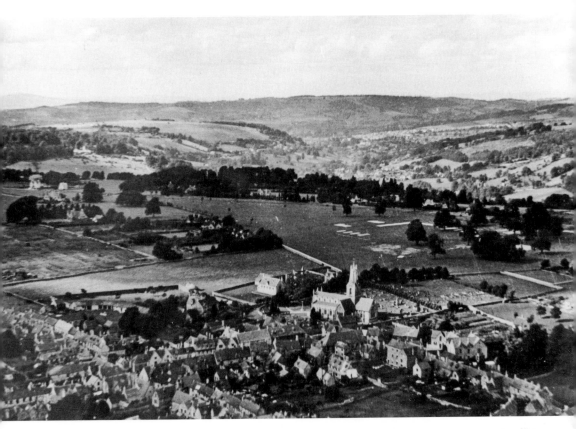

Aerial view of Minchinhampton in 1949.

'Saturday mornings in Minchinhampton reminds you why you love country living. It's a huge social occasion with people dashing to buy their fare, and the town has come alive. It has a heart and a soul which is priceless.'

Peta Bunbury

I was wondering if I might ask you just a few questions...

- Have you lived in Minchinhampton or this area all your life?
- If not, what first attracted you to this area?
- How do you feel Minchinhampton compares to other places that you have stayed or even lived, especially in terms of the people and how they interact as a community?
- How did you first become involved in...?
- What changes have you noticed over the years both in your own personal circumstances and the community as a whole?
- Can you describe what you particularly like or dislike about Minchinhampton?

- Do you have any strong memories of things that have happened in Minchinhampton over the years?
- Do you have any concerns or hopes for the future of Minchinhampton?
- How do you think Minchinhampton might need to change in order to remain a sustainable community?
- What do you value most about our little town?

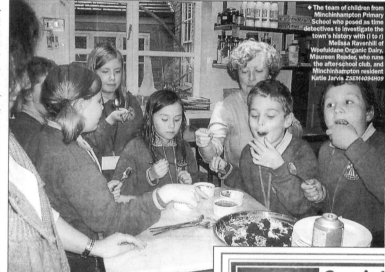

Wednesday, December 23, 2009 stroudnewsandjournal.co.uk

Scraps of information boost historical project

by Rachel Clare

A SCRAPBOOKING project initiated by Minchinhampton resident Maureen Reader and carried out by children at its primary school aims to chart the town's history in a new book.

A Valued Community, to be published in the new year, will include interviews from key residents, as well as photographs, illustrations and a wealth of information piecing together the jigsaw of Minchinhampton's history from the 1930s onwards.

Ten children, aged nine and ten, took part in an after-school club run by Mrs Reader where they interviewed residents and delved behind the scenes at local shops such as Sophie's Restaurant.

As part of the scheme, residents were asked to take part in a photographic competition and provide photographs of Minchinhampton from the 1960s and 70s.

Lucky winner Hilary Kemmett was awarded a selection of luxury cheeses in a pine cheese case from Woefuldane Organic Dairy Shop in Minchinhampton's Market Square.

Mrs Reader, who lives in Hiatt Road, Minchinhampton, said: "I am really interested in social history and it was fascinating to see events from different people's perspectives.

"The children made great time detectives."

◆ The team of children from Minchinhampton Primary School who posed as time detectives to investigate the town's history with (l to r) Melissa Ravenhill of Woefuldane Organic Dairy, Maureen Reader, who runs the after-school club, and Minchinhampton resident Katie Jarvis *ZSEM4094H09*

◆ LEFT: Sophie Craddock, of Sophie's Restaurant, demonstrates her blow torch on creme brulees to the time detectives
ZSEM4099H09

Education

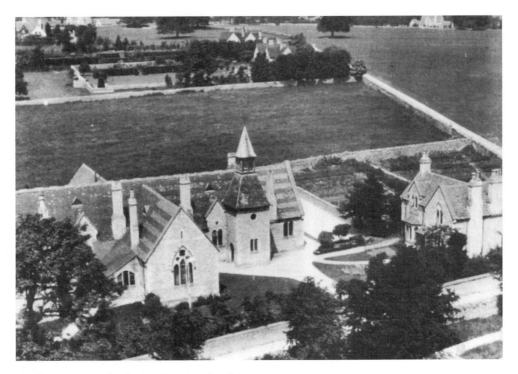

Minchinhampton School taken from the Church Tower, 1935.

Tell us your fondest memories of school?

- Who were your favourite teachers?
- Do you remember any trips or events?
- How do you think schooling has changed from your day?

My schooling during the war years

I was born in Minchinhampton, and I have lived here all of my 83 years. My parents were both from around here and my grandparents as well. We didn't get around much in those days you see.

Well, when I was thirteen years old the war broke out, that was in 1939 and I was at Stroud High School then. We had to carry our gas masks around with us all the time and they dug trenches in our lovely playground that we had to go into when the sirens went off. This was when the enemy aircraft were about.

My dad was in the army during the First World War, The Great War. He was badly injured when his leg got hit and the bullet went through his leg. He was taken prisoner, and the Germans kept him there, and luckily there was a Canadian doctor who was also a prisoner of war there. He managed to save my dad's life but unfortunately his leg had to be cut off.

We had no sweets and everything was rationed; bread, sugar, tea, even fruit was very difficult to get hold of. There were no bananas or other things that had to come from abroad. Life was very hard but we still carried on with our schooling.

Nowadays, I think you are so lucky, you have so much in your schooling. We had nothing like this (as she looks around the colourful classroom). It was basic, going to school at nine o'clock until four o'clock, learning the basics. We didn't have a Sports Day, as such, but we did our sports up on the Park. We didn't have this lovely grassy area that you have now, to play football and whatever.

Punishment in those days was also much harsher; there was the cane, of course, that the headteacher had, but also the ruler. If you were naughty, caught talking or whatever, the teacher that happened to be passing by, you had the ruler across your knuckles. And apparently this was still around in the 1960s as well. And the headmaster, if you weren't careful, he'd hit you under the chin. We wrote with just a slate and chalk in those days.

I remember being sent out from Mr Toms class, for being naughty. 'You go outside there Ellins', (teachers always called you by your surname), 'You go and stay out there until I fetch you back'. Well, I was frozen, and I was wandering around out there, and I looked up at the boys playground, (the boys and girls had different areas of the school then), and the sun was shining up there, so I was off up there. I was up there a long time, I would have been eleven at the time, and I was doing handstands up against the wall. Well after a while I thought I'd better go back, and as I came back into the lobby Mr Toms happened to be going out. He said, 'Where have you been Ellins old girl?'

'Well Sir,' I said, 'I was very cold so I've been up there in the sun'.

And he said, 'I don't blame you old dear, I don't blame you, so come on in and warm yourself'. So always tell the truth and you might get away with things. He hadn't said where have you been or anything like that. He had sent the girls out but they couldn't find me.

Poppy Cooke, born 1926

To school on my trusty black bicycle ...

I was born in 1945, and grew up in Burleigh, in the 1950s. We moved to this house on Park Terrace, Minchinhampton, when I was twelve, and I've lived here for 52 years.

I went to school in Minchinhampton, getting there on my black bicycle as I call it, at first with my Mum and then on my own. If I didn't go on my bicycle I was picked

up by one of the Ellins Family, who drove the lorry for Simmonds, the builders. Even in snowy weather I'd continue to go across the Common to school. When I was 12 we moved to Minchinhampton.

... and Inspired to a lifetime passion for gardening

I stayed at school for lunch, like most children. Mrs Randall and Mrs Perkins, they were the cooks in those days. All the dinners in the school were freshly cooked in school, of course, nothing coming in by van.

The only thing I didn't like about the school dinners were the diced swede, they did make us eat the swede, but the cabbage was lovely and often grown on the school vegetable patches.

In those days we had a school garden running parallel to the school wall next to the Park and Mr Robinson, the headteacher, he lived in the school house and we used to plant up the flower borders next to the school house, and the lower part. Around the school grounds we planted dahlias in the summer and wallflowers in the autumn, ready for the spring. We didn't really grow vegetables in a big way at that time, not for the school kitchen, but it did set me on my ways to a lifetime of gardening.

As far as school sports were concerned, the teachers didn't used to organise after-school clubs, although we did used to play cricket on the Common. I remember a cricket match that we had on a Saturday morning, against Thrupp School. Mr Riddiford, the headteacher there, did the umpiring and John Heavysides and us youngsters, we organised a match on the Park.

For secondary school I used to just walk down to the school at Brimscombe. I used to enjoy cycling down to Winstones ice-cream factory at Bownham. Albert Winstone, who founded the business in the 1920s, was at school with my Dad.

John Bingle, born 1945

Miss Beale

Miss Beale founded and ran Blueboys School, just off Minchinhampton Common, for 34 years from 1948 to 1976. It was named Blueboys after the Minchinhampton lads who once worked in the wool industry, stirring the vats where the cloth was dyed blue.

'When we first came down, we had bicycles, of course, and a pony and trap. In those days, your friends were all at the end of a bike ride – we knew very few people on the other side of the hill. Nobody had a car except for Dr Brown.'

Minchinhampton School 1952 to 2010

In 1952 there were two schools in Minchinhampton. Mr Robinson was head of the juniors in charge of four teachers; there were about 220 pupils. Miss Beard was in charge of the infants, leading three teachers and about 100 pupils. Mr and Mrs Robinson lived

in the School House from about 1927 to 1960; next to the school itself which was a small Victorian building housing only limited classroom space. The Market House was therefore used for assemblies and special occasions.

In May 1969 a new school building was opened. Lord Butler was one important guest, and he was, at that time, the owner of Gatcombe Park.

In 1977, at the time of the Queen's Silver Jubilee, there were 426 pupils, with 14 teachers as well as the headmaster. Terrapins had to be built next to the school to accommodate the increasing population.

In 1999, a new school building received the Royal seal of approval when the Princess Royal performed the opening ceremony. The Princess, who lived at nearby Gatcombe Park, arrived dressed in a black and green tartan skirt and green blouson-style top, rather than a tiara and ball gown. She spent an hour touring the classrooms and nursery unit with headteacher Rod Harris, chatting to pupils, teachers and guests.

The old Victorian schoolhouse

Moving onto education, this was, for our two girls, the first consideration when we moved here, and we were delighted to find the headmaster, Mr Bosley, was very positive.

We also found that most of the new occupants of Beacon Park represented business and professional 'rising stars', with many qualified lady teachers more than pleased to fill teaching vacancies as demand rose. In this case we found the quality of teaching to be excellent. Additional classrooms were also acquired as the population rose.

Peta: Of course I was in the original old Victorian school, back in the 1960s. You mentioned Angie Ayling, yes, I knew her as Angela Cornwall in those days. I was in the same class as her brother, Leonard.

Rees: Yes, her father was the local clergyman.

Peta: I remember Miss Bassinger's classroom. We'd first walk into this beautiful old cloakroom where we used to queue up to get our bottles of milk, then you'd turn left into what seemed at the time to be a huge classroom with a great furnace in the far corner – that kept the place warm. So there were two classrooms in the main building but if you went out alongside the building past the playground you came to a separate bungalow which was Miss Halford's classroom. That was the class you went into when you first started, and then you went into Miss Fassnidge, then you went to Miss Mathews. And that's when they had to build lots of terrapins to accommodate the big influx of newcomers at that time. So then they went on to build the second school in the 1970s, and that was situated at the top of the playing fields. And again that outgrew itself with terrapins, so they built the present school back where it was originally, about ten years ago.

Rees: We mustn't forget there was a small private school up at Blueboys corner, run by Miss Beale. Princess Anne's children went to school there. This was great because

Yet the success of Minchinhampton School lies at a very different level – simply in the passion, commitment and dedication shown by the staff towards their work with the young people in their care. During my years at the school, the world's technology has continued to evolve at an unbelievable pace. In 1996, mobile phones were like bricks, MP3 players and iPods were a fantasy, videos tapes were the best thing since sliced bread, only 1 in 5 schools had the internet, now 99% of schools have broadband. In 1996 who would ever have thought of inter-active whiteboards? Myspace, MSN, Bebo and Facebook were just words that had no meaning. The first hard drive for an Apple computer had a capacity of 5 mb, internet was downloaded at 5 kb per second, today the pcs our 5 year olds at school use have a capacity of 2GB of memory and the internet downloads at a minimum of 8 mb p/s. In 1996, a virus was something you caught and made you feel ill, today in the world of computers, there are 6,000 new computer viruses released every month.

What in the next 13 years ?! It is likely that many of our youngest pupils will live into the next millennium – what kind of world are they going to witness in that time. Their lives will certainly be a challenging and exciting adventure. I wish them good fortune.

The thoughts of Rod Harris, former headteacher of Minchinhampton School.

Rod Harris
Retired Headteacher, Minchinhampton School.

nobody expected royalty to use a local school, as well as Mrs Tomlinson's nursery in the Scout Hut. It really uplifted people's feelings about their own community.

Peta: Yes and Miss Beale is still alive today, tottering around Minchinhampton.

Peta Bunbury, born 1962 and Rees Mills, born 1929

A flight back from France

Where did I grow up and go to school? Well, in Reception I went to Beaudesert, but that wasn't for long. I was in Year 2 when we came back to Minchinhampton. We had been living in Cognac. The school felt bigger because you had Reception in one building, Years 1, 2 and 3 in another building then Years 4, 5 and 6 in another building.

I stayed for school dinners and they made you eat every single thing on the plate, even if you didn't like it! They were much stricter over there, in class as well. When I was in my last three months I started going home for lunch.

As far as speaking the language, I did speak enough French to get by but then I forgot it all when I was back in England, in Year 3.

Another thing I can remember is that we didn't wear school uniform. We got to wear absolutely anything we liked, all through the school. You could have even worn a bridesmaid's dress if you'd wanted to.

Also, we didn't go to school on Wednesday but we went for half of the day on Saturday. But, come to think of it, the Reception didn't have to go into school on the Saturday either, that was just for the older children.

Phoenix Lewis, born 2000

Growing up then moving on

(A cosy chat next to a log fire, a deep layer of snow outside and a full moon, just a few days after Christmas).

Rachel – (born 1989): I'm in my third year, studying music in Bangor University.

Henry – (born 1990): I'm at Leeds University, also studying music, but a different type of music to Rachel's.

Roger – (born 1993): I'm studying for my A Levels at Cirencester College.

Howard – (born 1995): I'm at a school near Cirencester – Rendcomb College.

Howard: I think I probably have more friends in Cirencester than I have in Minchinhampton, actually. I guess because I went to secondary school in Cirencester, Deer Park, made loads of friends there, and didn't really feel the need to meet up with friends in Minch after that. I must admit I made better friends at secondary school.

Rachel: I've made friends in Minch through my job at the Crown in the High Street, I know a lot of local people through that. I do keep in touch with some of my friends from primary school because there was a few of us that also went on to secondary school in Cirencester.

Roger: It's pretty much the same for me as well – most of my friends are in Ciren, but I do have a couple of friends in Thrupp and Brimscombe as well, which I meet up with from time to time. I still see people from Minchinhampton, but not as close friends. Moving from Minchinhampton Primary School to secondary in Cirencester felt like a big jump but once you're there it's okay.

Henry: It's the same wherever you go – college, university ... I mean, at secondary school you have a bigger pool of friends to choose from, and of course at university it's even bigger, more people to find something in common with.

Howard: Well, I'm very different, again, because I have moved schools a bit, most of my friends in Minchinhampton. I still play in the football club here, once a week, although I don't really socialise with them. I do have some friends from Rendcomb School in Cirencester, and in fact a few of them do live in Minchinhampton. I've just started at Rendcomb; I was at Pinewood, near Swindon, for four years before that.

Rachel: Special memories that I have of school – well the art and design teachers at secondary school, but at Minchinhampton Primary, Mrs Arnison. She really started up the school orchestra in a big way, and I know that that is still going on today. She was a really good teacher and she certainly inspired me in my love of music. I didn't realise how much of an influence she had been until a few years later when I had to sit an interview. There was Mrs Hale teaching music as well.

Henry: I thought Mr Harris was great; when he came to our lessons he made it exciting, and when he took the football, we had fun. He was like a big dad; he knew every kid and always had time to talk to you, very approachable.

Howard: I remember Mrs Hugginson; she was very nice when you got to know her when you were a bit older, but some of the boys in my class used to wind her up a bit.

Rachel: I remember Mrs Andrews; I liked her but she was quite loud, and Mrs Atthey.

Roger: Miss Ayres was nice.

Henry: And there was Mrs Smith; everybody was scared of Mrs Smith until they got to year 6 and had her; they realised she was actually quite nice.
Howard: Then there was Mr Newbould – the only teacher who wasn't a woman.

Henry: Although there was Mr Jackson before him; he was really funny.

Rachel: Oh yes; I remember he always carried a teddy bear in his pocket.

Henry: Oh, and he ran the football club. He always told jokes as well, and called us 'sausage'. There was a Mrs Jackson that came in for a couple of years as well.

Howard: Mr Newbould took the cricket club didn't he, and did the computing?

Rachel: As far as transport was concerned for getting to other social life – well, as soon as I turned seventeen the first thing I did was to aim to pass my driving test, stuck in the middle of nowhere. A lot of it was going to Cirencester College and to see friends. I did go to Downfield sixth form in Stroud for a year, completed my AS Levels. I didn't like it. I think it was harder for me, well a group of us, because we hadn't been through Stroud High School it was harder for us to be accepted by the others. There was a group of us that had come from other schools; we didn't feel very welcome there, stayed a year and left at the same to continue with our A levels elsewhere. That's when I went to Cirencester College. Downfield was too much like school, as well. We wanted to be treated more as young adults.

Henry: I really enjoyed Cirencester College.

Howard: Because I only spent half of my primary school years in Minchinhampton I've always felt a bit detached. I do have a couple of friends from school that live in Minch

Mrs Andrew's reception class, 1985. Do you notice anything about the children's clothes?

and so we do do lift shares sometimes. I have breakfast in school because my mum teaches at Rendcomb anyway. She teaches in the junior school; she's head of maths, teaches DT, a bit of science, and she's a form teacher. The hours – well, registration at about 8.15 a.m. then, depending on prep, sports and so on, we usually go home at about five o'clock. You can stay for prep which is quarter past five until ten past six, then there's tea and the boarders stay.

Roger: From my point of view, as far as friends from primary school – I've naturally lost touch with most of them, because I don't see them so often. I've been through Deer Park, and most of my friends are in Cirencester College. I'm now studying biology, chemistry, music and archaeology at A Level. But now we have Facebook, I have recently regained touch with many of my primary school friends and it is brilliant to hear from them.

Henry: There is one best friend that I've known since the first year of primary school, here in Minch; fourteen, fifteen years, I've known him now. I do still keep in touch with him. He's at Southhampton, doing engineering.

Rachel, Henry, Roger and Howard Auster, born 1989, 1990, 1993 and 1995

Moving on to secondary school

My favourite teachers at primary school; I liked Miss Tonner best, and Mr Harris, the headteacher. He was really good. I left Minchinhampton School last July and now go to Thomas Keble School in Bussage. The food's good there – that's it really. I'm still getting used to secondary school. I like the bus rides into school, they're good. We have a joke with the drivers, the friendly ones anyway. There's one lady who, we say things like, 'Al right darling ...', and she laughs. Some of the drivers can be quite strict, if we're messing around too much, but they're okay.

Kieran Hart, born 1990s

There are so many young single mums here that you just don't hear about

David Boyd's allotment up on Tobacconist Road; actually, we are using it a bit for our playgroup. I'm the third generation of play leader up at the Coigne Playgroup now. When Doreen Slater retired last year we had a photograph taken of Angela Keen who was the original leader, Doreen and also myself, as I took over the job. It was originally in that lovely old building, The Coigne, on the Market Square, until a few years back when it outgrew itself. I think when Mrs Keen gave up, the playgroup moved out, because, of course, it was in her house – I guess. I think there were health and safety reasons for moving out as well. There were lots of tiny rooms.

Where we have the playgroup now, it is so much better geared up for this sort of thing. It has a big hall space for children to move around in, on tricycles and so on; but it also has spaces going off it which allow other activities to go on but in the same space.

The building doesn't look particularly attractive on the outside but there is a lot of renovation going on, certainly on the other side. I think the Baptist Church is taking it over; it has been gutted completely, with new flooring, toilets, and new kitchen facilities. I had wanted it for the playgroup but we just couldn't afford the rent.

At one time I had it in mind that what I wanted to do was to run sessions, parallel to the playgroup, for the really young mums, because there are so many of them in Minch. When they come up with their two-year-olds, these sixteen, seventeen-year-olds; they seem so isolated. It's surprising, but there is such a cross section here, that you just don't hear about, generally. Most people only know about the wealthier side. These girls just need somewhere that can offer a bit of stability, really. I'm sure Andrew Brooks at the Youth Club has said the same sort of thing. Just to have a place for the mums to come, to have a cup of coffee, a chat with other mums of their own age group, and perhaps also a bit of advice and support, that's available every day almost, when the playgroup is open.

It's so important to me that the Coigne keeps going. It has been going for so long, providing a service that, let's face it, at £8 a morning, instead it is more affordable than the other playgroups and private nurseries in Minch. It's a huge responsibility being at the helm.

I know it used to be that Gill Thomlinson's nursery group catered for the wealthier end of Minch and the Coigne served Glebe Road. We're a charity and we rely on the generosity of volunteers with a rota of helpers.

There were rumours that the Doctors Surgery wanted to move up to the Youth Centre building as well because they need more space. It's such a tiny surgery next to the school. But if the surgery were to move out of their present building, that would be ideal for our little playgroup and so handy for the school, the library and the shops – right in the hub of things.

Sally Lewis, born 1970s

From Blueboys School to Stroud High

I was born in Devon in 1965, and then moved to Amberley when I was 6 months old; my parents bought a hotel in Amberley called the Hawthorn Hotel.

As far as Minchinhampton is concerned – I went to Blueboys School; then I went to Stroud High School. I remember the head, Miss Beale, at Blueboys; she taught me, and then Elsbeth Bland eventually took over. This was during my last year there.

Princess Anne's children, Zara and Peter Philips, went to Blueboys; Peter until he was 7 and Zara until she was 11, I think, then on to Beaudesert.

Lucy Offord, born 1965

Life in Minchinhampton School from the 1990s onwards

Have you lived in Minchinhampton all your life?

Pat: I've lived in Minchinhampton most of my life, since I was ten. Prior to that I lived at Swells Hill, which is about three miles away.

After we got married we lived in Nailsworth for ten years, so we've stayed local.

Sally: I've never lived in Minchinhampton, but I was born and brought up in Gloucestershire.

I grew up on the other side of Cheltenham, on a farm. That area has become very built up now, unlike Minchinhampton.

What drew you to this area in particular?

Pat: My parents actually moved here from the Welsh Valleys, when I was two. I had always had asthma and bronchial problems, and they were told that they had no choice but to move me out of that environment. I can't remember why they chose the Minchinhampton area. My dad got a job here first at Hoffman's in Stonehouse, which is still an engineering company – but it goes by a different name now. He would cycle every day from Swells Hill to Stonehouse, and that was the norm for people, of course. They didn't consider it a chore to cycle for an hour every morning and every night. I guess it's just like people these days who think nothing of an hour's drive to work each day. As children, we walked everywhere.

Sally: I personally came back to Gloucestershire in 1986, from Kent. I got a job for three years, as a housekeeper at Edgeworth House, on the other side of the valley.

Then I thought that I'd like to get back to what I had been trained for – to do nursery nursing again. Mr Baker, the headteacher at the time, gave me a job.

That was in December 1989, and I've been here ever since.

I think I was drawn to a job here because it was a country school. There were jobs in Gloucester and Cheltenham but I just didn't want to work in a big town. And when I lived away from Gloucestershire I had always chosen to live in the country.

Years 3 and 4 performance of 'Dream On', Minchinhampton School, 2009.

How does Minchinhampton compare to other places that you have lived?

Pat: I started working here in Minchinhampton in 1993.

Comparing Minchinhampton to other places that I have lived, well, I was at college in Kingston-on-Thames. That was a very different of community, of course, more built up and a faster pace of life, generally. What I loved about it was that you could go everywhere on public transport, and be back late at night without worrying about missing a bus. As a child, in Swells Hill we had to be back early, before dark; being out in the country, there was no reason to be out late, after 9 o'clock.

What changes have you noticed within school since you first started working here?

Sally: I have seen so many changes within Minchinhampton School, since I first started here in 1989 – a new school building for a start.

Pat: Yes, and we've had various headteachers since that time. Joyce Thomas was acting head for about eighteen months; then Rod Harris was appointed in 1996, of course.

The number of pupils has gone up and down over the years.

Sally: Yes, when I first came here we had ten classes, but then we went down to nine, but not huge fluctuations.

As far as staffing is concerned, there has been a huge change in the number of teaching assistants. When I first came here I was the only other member of staff, involved with the children, who was not a teacher. I came here as an NNEB nursery nurse because that was what they wanted at the time, to work with the younger ones.

Pat: I was the next teaching assistant to be taken on, about five years later. It was a government initiative to try and support the early years in particular. This was in the mid-1990s.

Sally: But having said that, last year was the first year that it was compulsory to have a teaching assistant in Reception class. I mean, Mrs Andrews had been campaigning for a full-time teaching assistant during all of the eighteen years that I had been working with her. Now she has retired.

I mean, I was shared between Reception and Year 1, as well as the Year 2 classes. I just changed classes after playtime and things like that.

Pat: I've noticed changes in the number of parents who come into school to help.

Sally: Although, I'd say that this has gone in phases. There weren't many when I first started, but then Sandra encouraged, so yes, it has been the teachers who've encouraged, and it depends on whether the parents want to do it of course.

Pat: Yes, that's how I became involved in this school. I was a parent helper here for ten years before I actually got a job here. I always came in all day Friday to help with art, crafts and sewing, in different classes. My two children came to school here. I came in to support – not the classes that they were in, but to help the teachers when they were doing practical subjects. I sometimes helped with reading, but not often.

Sally: My son came here to school when I started, as a Year 5. Mrs Andrews' children didn't come here but Mrs Blythe's did. Mrs Blakelock, as well, had her two children attending here. I think she left in 1998. She got a headship elsewhere. Then there is Mrs Powderly – her two children came here. In fact most of the teaching assistants, they're more local, and their children have been through this school.

How do you think the children have changed over the years?

Sally: The pupils that come into school nowadays, their listening skills are not as good.

Pat: Yes, of course, society has changed; more TV is watched, people don't have meals around the table as much as they used to, and children often play alongside each other – not with the other children. With their computer games and so on they don't interact as much, there doesn't seem to be the make-believe games that there used to be.

Our new school, opened 1999. Our new headteacher, Mr Nick Moss, October 2009.

Sally: In the dinner hall, with their hot lunches, some of the children struggle to use a knife and fork properly.

Pat: A new initiative that Mr Moss has introduced is for teaching assistants to participate in running small groups in clubs. We've got Eco-Warriors, Librarians, Charity Group, Monitors and the School Council.

Mrs Powderly and I have a group of Key Stage 2 children making the pupil multi-media magazine. They are the News Reporters. This will eventually be on-line (on the school website), using video footage, photos, reports, and these pupils will be reporting on things that they have maybe done in school, visits and so on.

Sally: My Eco-Warriors are trying to make the school more environmentally friendly; thinking of ways to, you know, reduce, re-use and recycle. We've only just started, and of course to begin with they had all these grand ideas about saving the world, but now they've come back down to earth, and they know that we've got to start in our own environment. We are looking at encouraging everyone, the office and the classrooms, to recycle the plastic milk bottles, paper and we've been doing composting for over a year now. The huge metal tins that they use could certainly be recycled, but it's finding the time to take things out to the bins and this is where the children come into it. We need to get everybody on board to do it.

Pat: I'm sure it's the same for Transition Minch with the composting, wood gathering and growing your own vegetables, plus the car sharing when you go shopping; the basic things.

Sally: We're also thinking of planting a wildlife area right in the top corner and there could be a compost heap there, and we've already got the large pond area for pond-dipping and nature studies, of course.

Pat: There have always been after-school clubs since I started. I know when my children were here there was something for them almost every day of the week – certainly for the older children. We have the other clubs: football, cross country, hockey, martial arts, mad science, dance, art, tennis, country dancing, athletics, nature quiz, recorders,

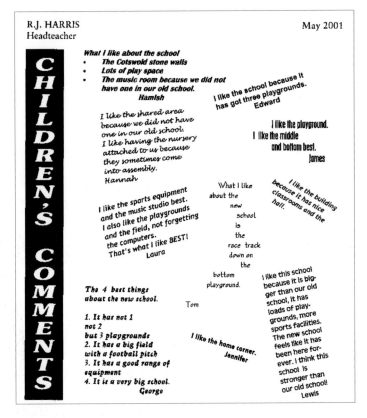

R.J. HARRIS
Headteacher

May 2001

CHILDREN'S COMMENTS

What I like about the school
- **The Cotswold stone walls**
- **Lots of play space**
- **The music room because we did not have one in our old school.**
 Hamish

I like the school because it has got three playgrounds.
Edward

I like the shared area because we did not have one in our old school.
I like having the nursery attached to us because they sometimes come into assembly.
Hannah

I like the playground.
I like the middle and bottom best.
James

I like the sports equipment and the music studio best.
I also like the playgrounds and the field, not forgetting the computers.
That's what I like BEST!
Laura

What I like about the new school is the race track down on the bottom playground.
Tom

I like the building because it has nice classrooms and the hall.

I like this school because it is bigger than our old school, it has loads of playgrounds, more sports facilities. The new school feels like it has been here forever. I think this school is stronger than our old school!
Lewis

The 4 best things about the new school.

1. It has not 1 not 2 but 3 playgrounds
2. It has a big field with a football pitch
3. It has a good range of equipment
4. It is a very big school.
George

I like the home corner.
Jennifer

Children's comments about Minchinhampton School, from 2001.

orchestra and choir. So there is a lot going on. Mr Newbould used to run the computer club and chess club when he was here, and I ran the church quest group.

Going back to the changes that we've seen since we started working here, the big change that I've noticed over the past twenty years is the number of children that arrive at school in cars. Mr Harris tried to address this with the 'walking bus', where parents were encouraged to take it in turn to walk to school, collecting named children along the way.

Bicycle racks are being considered to encourage the older children to cycle to school.

Sally: And it's also the number of children that are late to school – twenty past nine sometimes. Whether this is due to more mums working or what, I don't know, but yes the transport issues have changed a lot and of course so many more mums do have cars now.

Pat: But we still love it here, and wouldn't want to work anywhere else.

Sally: I agree.

Sally Savage and Pat Dyer, born 1950s

Leisure and Celebrations

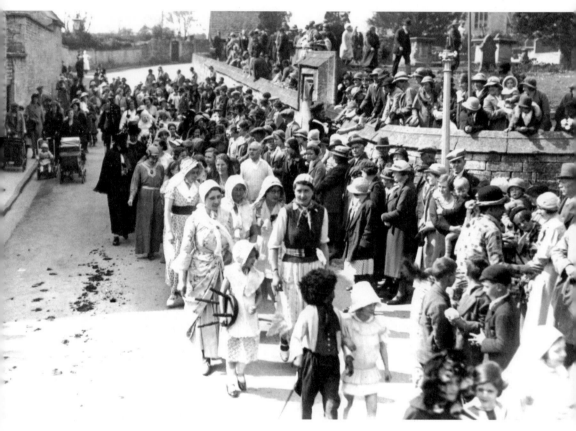

The May Parade, 1931.

The Whitsun Crown and Parade

Celebrations I remember that we don't have now; well, we had Whitsuntide. The Parish Church had theirs on Whit Monday and the Baptist Church had it on the Tuesday. I was a member of the Minchinhampton Baptist Church and we had the Avening band, and the Whitsun Crown was all decorated with lovely lavender.

We started off at the chapel, we walked all the way round the back of Friday Street down to the Market Square, where we sang hymns, then down to the top of Well Hill. We

went all the way up West End and sang, then back to the Sunday School where we had tea. Then it was on to the Park where there was always a fair going on at Whitsuntide.

There was also Maypole, pageants and a carnival at other times of the year.

Minchinhampton's social clubs; well, we just had the British Legion for the war veterans, which is now the men's club, (Cotswold Club), cubs had not yet started up. We had five public houses, and the Youth Club started up in around the 1950s.

Young people at the Youth Club in the 1950s.

A question for the children; 'Looking at this slide of young people in the youth club in the 1950s, how old do you think these people are?

'Oh, about in their twenties?'

'No, in fact they're probably mostly sixteen and seventeen years old. People actually aged quicker in those days and the way they are dressed probably makes them look older as well.'

'Blimey!'

I remember when I belonged to the Youth Club we once stayed there all night because we went on a long walk, but I can't remember the rest.

Poppy Cooke, born 1926

A Royal Celebration

Thinking of celebrations; I remember as a lad going down to Brimscombe where we celebrated the Queen's Coronation in 1953. This was in the Brimscombe football meadow and they had the old fairground rides and games. Up here in Minchinhampton, the scouts built a huge bonfire on the Park and it was their duty to camp overnight and make sure nobody lit it.

I was very keen to be a cub when we were living in Burleigh; this was when I was six. I kept nagging, 'I want to join the cubs, I want to join the cubs' and eventually our paperboy, who was Gerald Ford, managed to get me in at seven. I remember going on a club camp in Hereford, I remember at Lugwardine on the River Wye, we were making a raft out of the reeds and I jumped in and went down the river by myself! They had to get me out eventually. I was about seven or eight then. That's something that wouldn't happen today, they have to be so careful. Adrian Smith was with me at scouts under my leadership.

Another trip that I went on, as a scout, was when I was twelve; I was selected by Stroud and District to go to Holland. It was the first time I'd been abroad. We camped at Zandvoort for ten days. There were about 25 of us that went; a great experience. We travelled on the train from Stroud, in the August time to Paddington, and then caught the train to Harwich, where we went across on the ferry to the Hook of Holland. It was a very rough crossing and the roughest the scout leader had ever experienced – a real baptism of fire.

John Bingle, born 1945

MINCHINHAMPTON MARKETS, FAIRS AND FAYRES

Diana Wall, Minchinhampton Local History Group

In this, the twenty-first century, we can often fail to appreciate just how important the fairs and markets of the area were to people in the past. We can hop in the car and go to a supermarket for our groceries, or walk to one of the Minchinhampton traders, or even choose our goods on the Internet. Should we need work, or wish to employ someone in our own business, help can be found at Job Centres or through newspaper, radio and television advertisements. Centuries ago, these functions, and others besides, would have been carried out in Minchinhampton at the twice-yearly fair, or the Tuesday market.

Clubs and Societies

There have been many changes in the past century in Minchinhampton town itself in terms of its social life.

Even as far back as the 1930s there was a wide range of sporting activities going on.

Cricket and football clubs catered for all ages; there were many events based around the church, the Minchinhampton Institute in Tetbury Street, as well as the British Legion Club (now the Cotswold Club).

The 1960s, however, saw the building of a new youth club and sports and social club, which helped to serve the expanding population and to bring in 'new blood'.

Obviously, with the increasing availability of the family car, the options to travel further afield means that local clubs have more to compete with when residents choose to spend their leisure time outside the town.

We try to make them feel a bit important, raise their self-esteem

How did I first get into youth work? Well, I stayed at the club for a long time and became a part-time worker there. I enjoyed it very much and a few years after I finished university up in Birmingham, I applied for the job as youth leader, and got it, and here I am today.

The club is really specifically for 13-19 year olds, but we do have another youth club for juniors. The younger group is for 8-12 years old and there is a big demand for that. We have about fifty juniors and probably about forty seniors. You need that number because they don't all necessarily come on one night, probably just 30 per cent at a time.

The children are very lucky up there, as far as games and activities are concerned. They have all sorts of sports; we've got five-a-side football, table tennis, pool, unihock – that's indoor hockey. They can watch television. The games that they play on the computer are closely monitored; children wouldn't be allowed to play a game that was way beyond their years.

For the older children we go on residentials, for the weekend; we go to South Cerney to do sailing and other water sports. We do get involved with the Duke of Edinburgh Award, to a degree, but I tend to take pupils from Thomas Keble, for instance, to allow them to do their community service, but the schools tend to push it more than we do.

We get all sorts of children, from all sorts of homes here – and they're all lovely!

And yes, we do sometimes have to deal with what we call some challenging young people, who are perhaps not as fortunate as some of our other members, in terms of support at home.

If we recognize any big problems then we tend to hand it on to social services rather than trying to tackle it ourselves, just as the staff would here in school. I don't really have the time to take something on one-to-one. I know the avenues to go down for the best interests of the young person, and I advise on the ways to go forward really.

As far as helping young people to be the best that they can be, in terms of being part of a community. Well, those that are interested and those that can be quite challenging, we try to give them a responsibility. We do that by asking them to work on the coffee bar, and we do litter picks, and generally encourage them to offer help to other people.

Tabitha: Do they get money for it?

No, they don't get paid. We say it's got to be voluntary and they do it because they want to. They get recognition. We try to make them feel a little bit important, to help to raise their self-esteem.

Maureen: How do you think teenagers have changed over the years?

Oh yes, they've certainly changed. Well, our whole culture as a society has changed. I mean the things we do at youth club they tend to have at home now, like televisions, computers, play-stations. You go back thirty or forty years, youngsters did come out more to try and find things to do. Now they've got it all at home, really.

Maureen: Do they ever say anything about their family life, the fact that they're going home to an empty house or ...?

Yes, they do; we know the ones whose parents have to work long awkward hours to make ends meet. I'd say the social mix now compared to how it was twenty five to thirty years ago is very different. Whereas in the past we had more of a mix of young people from both middle class and working class backgrounds, well, you don't get that now. It tends to be the young people from less well off backgrounds, but that's okay.

Andrew Brooks, born 1952

Minchinhampton Youth Club, Juniors

Oliver: We're all the younger ones – the juniors, aged between about 8-12 years.
 I've lived in Minchinhampton all my life, in the same house. I've always been at Minchinhampton School. My favourite teachers at school are Miss Piper and Miss Ayres because they're really nice and don't get as 'stressy' as some of the other teachers. I've been coming to the youth club for a few months now.
 I really like this youth club because I can just chill out with my mates and get away from my parents – they can be a bit bossy sometimes! Here, we can play pool, badminton, football down in the hall there, or outside on the astroturf, we go on the Wii, buy sweets from the tuck shop and do crafts sometimes, like making bags or just drawing. In the summer we have barbecues outside. We normally have about 10-15 of us here in the evening.
 My dad; he works on housing projects, and most of the time is able to work from home. Other clubs – well, I play for Golden Valley Football Club; that's over in Bussage, on the other side of the valley. I sometimes meet up with some of my friends up at the Glebe: Edward Carr, David Jeffrey and others, and we just mess around on the play area there.
 For secondary school, I'd like to go to Marling, and then become a footballer when I grow up.

Eliot: I lived in Stroud for a few years before moving here, a couple of years ago. Stroud is much busier, so I prefer Minchinhampton because it's quieter. We moved here to come and live with my dad who was living here. My Mum and Dad don't work. My Gramps is retired and Gran helps in the charity shop – Cotswold Care Hospice. I do after-school club football, the same as Ollie. I'd like to go to Marling as well.

Danny: Me and my sister, Abigail, over there, have just joined.

Liam: I've been coming to this youth club for more than a year. I like being able to run around, playing pool and people watch. I like people watching when strangers do weird things.

I was born in Gloucester Hospital but my mum brought me straight back here afterwards. Most of my family lives around this area, not just in Minchinhampton, but Stroud and Cirencester. My grandparents live in Nailsworth. My Nan that lives in Tetbury sometimes comes to look after me. My cousins live there as well.

I don't belong to any other clubs; I normally just go to my friend's house and we play on his computer.

After Minchinhampton School I don't want to go to Thomas Keble School. Their toilets are a long way from the classrooms.

I know where I would like to live – in Stroud, next to Stratford Park, where there are the cool swings, the duck lake and the mini railway. Or if I could live in another country I'd like to live in Zante, in Greece. I want to work with trains when I grow up.

January 2010

Brownies at the back of the Men's Club

Rees: When we first moved here the only sports that occupied the ladies was the tennis played down in Stroud, and it wasn't long before a committee was formed for the purpose of organising fund raising to create two tennis courts on the Stuarts playing field. We held lots of dances, at the old Bownham School, opposite the Bear Hotel, as well as the Youth Club in Minchinhampton. Since then, the playing field has, of course, been extended for football and cricket.

When we moved here there was the scouts up at Dr Brown's Road, used both for scouts and guides. The youth club was fairly new.

Peta: I went to Brownies, and in those days it was round the back of the Men's Club, (which at that time also housed the sports and social club.) They actually had a bowls club round the back, as well. That's where the Cotswold Club is now.

Rees: Well, the Market House, really, played the most important role, socially, in those days. It was the centre for community interaction.

Peta: One very important social event that has seen a lot of changes is, of course, the local bonfire. In the olden days the fireworks were never done by the school. It was done by the scouts at the back of the Scout Hut, but with the houses being developed around

it, it became too dangerous, so the Wickham-Georges, a well known family around here, in Chapel Lane, agreed to have the bonfire and fireworks on their land. This would have been in the early 1970s. At what point the school took it on, I don't know.

But going back to the youth club, the sports and social club was added onto the right-hand side of the youth club. This was rented by the rugby club at one time.

They're re-modelling it now, putting a new roof on and putting new windows at the side, but I'm not sure what plans there are for the building.

Rees: During the 1970s, of course, the Minchinhampton Operatic and Dramatic Society came alive, emanating from the new blood coming to the town. Terry and Joyce Thomas and Barry and Jill Woods built up a very large membership. The society won many regional prizes for their high quality performance.

Well, I personally did go to the youth club now and again. And then Gill Woods moved her dancing classes, in about 1980, to the youth club as well, which I also went along to, doing tap and modern ballet. This was part of the amateur dramatics. I wasn't so keen on the youth club because they just seemed to be hanging out – if you know what I mean.

I later helped behind the bar of the sports and social club. Pa had me up there as soon as it opened, but then it was all voluntary, so I eventually went to work in the Weighbridge down near Longfords, where I could earn some decent money.

But the youth club just isn't the same these days; there is more disorderly behaviour and, of course, because we no longer have a police station (that was relocated to Stroud), you don't have the constant presence of a local policeman. In those days people behaved. It's very sad – half the kids just don't seem to have any respect these days. I mean, I don't put hanging baskets out any more. The amount of flowers that have been ripped out of flower baskets – it happens all the time. Unfortunately it's the sign of the times.

Things have changed so much in the nature of a Minchinhampton childhood as well.

I mean, when I was young and we lived on Beacon Park, I would walk to school, from about the age of eight or nine. I'd walk with my friends and we'd walk over the Park and into school. Sadly nowadays parents feel it's necessary to walk or drive their children to school. The thing is because of the increase in cars, people do worry about their children's safety, and mums work as well, so they drop their children off on their way. It has just happened over the last twenty five years, really. There are so many cars in Minchinhampton it's ridiculous – everyone has one.

I used to go and play on the commons with my friends over at Besbury Common, playing on the trees, but I know that most people don't allow their children that kind of freedom any more; not until the age of twelve or thirteen anyway.

Peta Bunbury and Rees Mills, born 1967 and 1929

Art and Crafts

Minchinhampton's Art and Craft Group; I set this up back in September 2009.

It all started when I was doing a botanical illustration course over at Painswick Rococo Gardens. This was run by the WEA, the Workers Education Association. The

tutor agreed to come over to the Market House to give some botanical illustration sessions here. I then thought it would be good to invite a lady I know in Stonehouse who runs patchwork sessions. The seven week course, running from September, was botanical illustration and patchwork, every Monday morning.

The WI, even though they were told about the course, has not taken any interest in the course. I think the WI is a great organisation, and when I first retired I did join. Sue Smith, the chairperson, is a very good friend of mine, and I was with Minchinhampton WI for a couple of years, but the average age was about 75, and when so many of the membership is so elderly it doesn't lend itself to moving forward. They've got their own agenda and good luck to them.

So, then we decided to have a traditional skills workshop, where people could come along and learn how to knit, learn how to sew and do bag making, as well as silk painting.

Linda Nicholls

Minchinhampton Gardening Club

The gardening club warmly welcomes members and visitors alike. With meetings on the third Monday of most months, there is a regular offering of interesting talks that are packed with up to date information; ideas can be shared and problems often resolved.

With a Cotswold stone canvas folks might presume that the gardening club is only for the romantic rose and cottage garden plant lover, but that's not our only remit. From the plight of the bee to the secrets of good compost, the range of information is wide and varied. When I first arrived in Minchinhampton I quickly visited the gardening club and was made to feel at home. A small group of dedicated volunteers run the club and do so with great enthusiasm. So, the next time you see a poster for an up and coming talk, please come along; you will likely be inspired and may even be tempted to join one of the interesting outings, but most of all you will have shared an hour or two with other garden lovers, and the people, as well as the plants, really are a lovely bunch!

Michelle Thomasson

Down in Box Wood from 9 o'clock in the morning 'til 6 that night

Memories of growing up in Minchinhampton? Yes, I remember playing in Box Wood; we'd go down there at 9 o'clock in the morning, and be there until 6 o'clock at night.

It was good when the new Youth Club started in around 1963, as well. Before that we had the Institute, in the old chapel on Chapel Lane. There's still the British Legion, of course, with the men's section and the ladies section.

Before all this, we had Admiral Bevan's cellar, that's at the Grange on the High Street. That was a youth club underneath.

We have the Cotswold Club – everyone used to call it the men's club. They've got a skittle alley, table tennis, billiards, snooker, darts, coyts. Yes, I've been a member of the

A cyclist relaxes on a slope
near Minchinhampton, 1950s.

Cotswold Club for, oh, about forty years. I remember the opening times were between
12 o'clock and 4 o'clock then. There would be a queue outside waiting for it to open.
Bill Gosling, the man that ran it, he was very strict. I've served on the committee there
for twelve years. The club does raise money for charity but nowhere near as much as
The Crown – they make a hell of a lot.

The Cotswold Club has changed a lot over the years, especially when it comes to
women. A few years back, they offered a proposal to let women become members,
paying an annual fee, but the women turned it down. They can come in anyway, but
they have to be signed in by a member, as guests. I mean in my day, no women went in
there, up to about 1968. The place for women is not the kitchen sink any more, is it.

Changes to the Cotswold Club, well, they've spent a lot of money re-vamping it,
but they don't have all the sports teams that they used to have. The membership has
dropped back a lot as well, we used to have about 500, but now it's about 350.

Fred Price, born 1950

It would be nicer if we knew more people of our own age here

Rachel: My social life in Minchinhampton has only really taken off in the last couple
of years.

Howard: We know as many old people in Minch as young people. We go for morning
coffee at the Crown and we often play as a family band; we probably know many of
the old people in Minchinhampton through this though. We're friends of Eric Doughty
down there.

Roger: It would be nicer if we knew more people of our own age in the town, though.

Henry: I like going in the lounge side of the bar, whereas Rachel likes going in the bar, because of course she works there.

Rachel: I do go there quite a lot when I'm home. I've worked there for over a year now, when I'm home from university.

Howard: Other social life around Minchinhampton: well, of course, I've been playing at the football club in Minchinhampton for six years, since I was eight. We've got a very big team in our age group.

Roger: I know the under 15 cricket lapsed because they couldn't get enough people to do it, but it should be running again this year. It is a shame that the amateur dramatics folded as we all took part in it and really enjoyed it. I have many happy memories from it, and it was a great asset to the village.

Henry: I played football at Rodborough football club as one of my friend's dad's ran the football club there. I used to play for Minch at rugby as well. I used to be captain of the cricket team in Minch at one time. We won the league two years in a row. John Turton was our coach up to Under 13's but then after that we just did our own thing. We didn't have any coaching but we still managed to win the league without a coach. Now I play for the men's team.

Rachel: I used to do the Brownies and Guides.

Roger: Yes, and we did the Beavers and cubs, of course.

Rachel: Brownies; well, I went to the 1st Minchinhampton Brownies in the Baptist Church, run by Ruth Morris; I could never remember her name because she was always Brown Owl. And then there was Guides up at the Scout Hut with Debbie Smith in charge.

Rachel, Henry, Roger and Howard Auster born 1989, 1990, 1993 and 1995

I absolutely loved it all from day one

I started Brownies when I was eight, because I suddenly realised other people were in the Brownies and I was missing out. This was in the 1960s. I might have one or two photos from that era, but we just didn't take many photos in those days, did we. It just tended to be on holidays, not closer to home.

We met over at the men's club, in the skittles alley at the back. This was in the winter. In the summer we used to meet over in Box, because we were originally Box Brownies, and we met in somebody's garden. We played out of doors all the time, even when the weather wasn't perfect, or out on the Common.

Eventually, it turned out that we were spending more time in Minch than in Box, so they changed it to Minchinhampton Brownies. We moved to the Baptist Church

from the men's club, when they altered the men's club, whenever that was – probably the late 1970s.

I went all the way through Brownies and Guides, never really left, absolutely loved it all from day one. I went back to help as a Guide at Brownies. My daughter, Jeni, has done the same thing, helping in Helen Haddrell's Brownie pack at the Scout Hut, and then Rainbows as well, for a few years.

I wouldn't say that there have been any major changes to Brownies since I've been involved. We still play many of the games that I played as a Brownie, and the old songs, of course. We do have new games as well, but the most popular ones are the ones that have come down through the years. Brownie camps, well, we've been to loads of different places. There is Macaroni Woods, over towards Cirencester, and then there's Cranham, up past Bisley.

Cranham is the Scouting headquarters. We tend to go there because it's a nice place to be – very user friendly. We've been to Cowley, that's the Guide headquarters, up near Birdlip. The problem with Cowley is that they have big dormitories that sleep fourteen, so if one of the Brownies goes on the rampage, then they're all up. I prefer Cranham with its smaller units. We have themes every time we have a Brownie camp.

A couple of weeks ago we went to Cranham, actually, and we had a Cranham fashion week. All the sixes were different fashion houses, so we had the House of Chanel, the House of Gucci and so on. Each of the younger guiders dressed the girls up in tea bag paper, and they had to design outfits for the fashion show at the end of the week. We just gave them a whole heap of craft stuff and said, you design an outfit and we'll have a parade and so on. I was the Simon Cowell of the fashion industry and went and criticised. I remember there was one outfit that really didn't work, so they said it was for an astronaut, and it was called the 'fastronaut'.

We have had some very memorable Brownie camps. We went to Bleden near Weston Super Mare; this was in a scout hut, so we were all sleeping in one room, which was quite interesting.

Both of my daughters are guiders as well, actually; Jeni, who is now 24 years old, and my other daughter, Vicki, who is 26.

My concerns for the future? Well, with Brownies, I'm concerned that people just haven't got the time to volunteer as new leaders. People are happy to help, but it's a big commitment if you're in charge. Because I've been doing it for so long it's second nature, but there is a lot of planning behind the scenes. It is very time consuming, and people don't tend to appreciate that. They think it is just an hour and a half each week; it's more like three to four hours, and you're constantly thinking about it – 'Oh that will be a good activity to do with the girls', and so on.

Jeni and Vicki are both leaders, but they don't want to take it on to be in charge. It is not just fun stuff, and the activities which I love, but it's the really boring stuff that I really hate – the paperwork and the finance. James, our Minchinhampton Cubs leader, feels the same way, and if you could get two people to run it together who were good at different things, you know, a people person and one who is good at paperwork; then it's an ideal partnership. That's an ideal scenario and I don't think it happens very much these days, not when it comes to voluntary work.

Other memories? Well, we did move to Bussage when I was in my teens. I called the house Colditz because I hated it over there! We had a beautiful big house in

three quarters of an acre that dad spent two years doing up. But it was in the middle of nowhere, as far as I was concerned. At that time, when I was sixteen, living in Minchinhampton and going to Stroud High School, Minchinhampton seemed to be the centre of all social activities. All of my friends who lived further away used to come and stay with us because Minchinhampton Youth Club was at its height. It was the place to be in the 1970s. And so to move out and suddenly find myself having to ask for lifts to places didn't sit very well at all.

It's the other way round now, of course; teenagers find themselves looking for a social life elsewhere.

Ruth Morris, born 1960s

When I leave school I want to join the army

The social life around Minchinhampton – well, there are places where we can meet up. There's a park up on the Glebe that's good. I live up there. (Ryan, Rus and Emily are hovering in the background, agreeing with Kieran).

But apart from the youth club there's not a lot in Minch. We go on the astroturf sometimes, kick a ball around; it's something to do on Saturdays. Andy, over there, is a pro-skater.

There are buses that come to Minch, but we have our own transport – our mums ...

What gets me is that people in Minch like to call this a village, but it's a town. It's too big to be called a village.

When I leave school I want to join the army, travel and get adventure. (The others don't know what they want to do).

I don't want to stay in Minchinhampton all my life – I think I'll move to Stroud. But then again I might be happy to stay here, find a place of my own, settle down and have some kids.

I'd recommend Minchinhampton to old people because it's quiet and has lots of good things for them, like clubs, and the allotments just opposite here.

Kieran Hart, born 1990s

My social life has grown elsewhere

Social life around Minchinhampton – not very much.

Having opened the shop here, I am starting to get to know more people but to be honest they're all adults that come in on a daily basis. I don't really have any friends based in Minch – although I must say that Minchinhampton does have quite a nice atmosphere, and everyone is pretty friendly. I tend to spend the majority of my time in either Gloucester, Bristol or Cheltenham, purely because most of my social life has been based around there. This does involve a fair amount of travelling.

Obviously I'm at the age now where I have my own group of friends, and unless there were something of specific interest to me around Minch, there's no need for me to

socialise here at the moment. All of the things I do are based elsewhere really. Clubs: I DJ a bit and I skate a little bit. I ride bikes, I mess around with cars and I generally go out in Bristol because my girlfriend lives there.

Henry Ravenhill, born 1985

'I'll be with you in ten minutes'

As a child I could get to Minchinhampton from Amberley, within about 10 minutes, across the common on my bike. I had a racing bike and I'd phone my friend in the middle of Minchinhampton and say, 'I'll be with you in 10 minutes', and I'd be there.

I spent most of my teenage life in Minchinhampton because of the youth club. I mean I had so many friends up here. My best friend was Kate Sands, of the Sands family who own the gentlemen's outfitters in Stroud. Then there were the Crytons; they owned the old vicarage, on the narrow bit of Friday Street. I remember the vicarage being really cold in winter, and waking up with ice on the windows. This was when I used to go for sleepovers there. Messing around with the boys in Minch, having egg fights in the Market Square, drinking alcohol on the common, and just having lots of harmless fun outdoors, really.

Lucy Offord, born 1965

Leisure and Celebrations

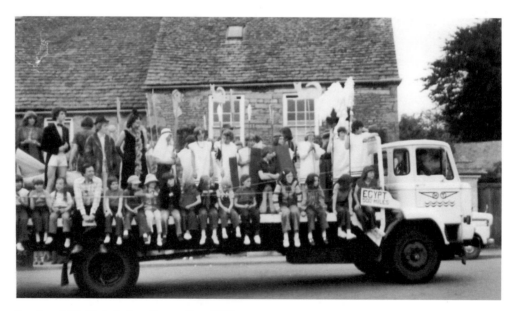

Joseph and His Technicolour Dream Coat, 1978.

Flags in Minchinhampton High Street, 1977.

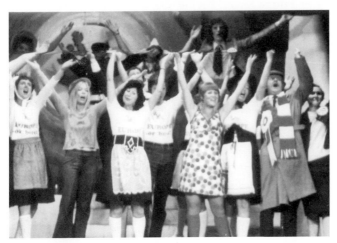

Some of the cast of *Nice and EEC*, produced at the Market House by Joyce Thomas.

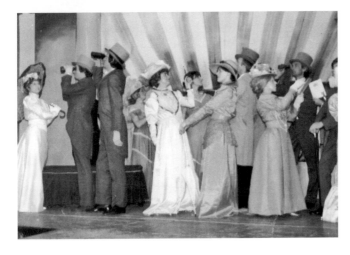

Some of the cast of *My Fair Lady*, produced at the Market House by Joyce Thomas.

'Incomers'

'Welcome to Minchinhampton'

During the 1960s and 70s the character of Minchinhampton changed considerably as a result of the growth in population. New housing estates were built to accommodate the incomers, as well as a new school, doctors' surgery, library, youth centre and sports association.

Changes afoot

In the 1960s and 70s, of course, all of the new housing estates were being built; there was quite a thing going on with the Parish Councillors. The man that sold most of the land up at Besbury Park; he made a lot of money out of it. I think there had been a quarry up there originally.

How did most people feel about the housing developments at that time? There wasn't really any bad feeling shown towards the 'incomers' but just the people that made so much money out of it. There weren't any riots, no, ho ho ... this is Minchinhampton we're talking about, after all! There was a bit of hate mail in the *Stroud, News & Journal*, but the locals just took all the changes in their stride really ...

Colin Shellard, born 1940s

From a large city

Going back to my beginnings in the London area; obviously London is very different to Minchinhampton – a large city, frenetic lifestyles, large buildings and obviously a very different style of architecture to the country life of Minchinhampton. That's partly why my background is on the commercial side. That always gave me a great buzz because the buildings were often very fascinating to design, very technically challenging and often very big, which is often a challenge in itself.

I do miss the buzz and convenience of the city, but the open spaces, the better quality of the air and the better lifestyle more than compensates for this.

Moving to Minchinhampton twenty years ago, the demographics of the town was such that there was a majority of retired people; a relatively small number had actually been born and bred in Minchinhampton. If you look at the estates around Minchinhampton they are designed for an incoming population rather than the existing population.

The school, the doctor's surgery and the shops, they are obviously at the heart of the community; they were expanded in the 1960s and 70s in order to accommodate an incoming population, and they are still the focal point of the community. But of course, the school only serves children up to the age of 11-12 years and then they have to effectively move out during the day to outlying towns and cities for their schooling, and their social life moves out of Minchinhampton as well. It is very difficult to replace that when they come back, perhaps to find work as older teenagers.

Chris Stone, born 1960s

Our consumer driven society

I came to Minchinhampton with my husband and daughter just a couple of years ago; we had been living abroad for quite a few years, 9 of which were in Southern Spain. We moved back to England during the winter; it was a bit of a shock and it has taken me a long time to warm up, but we love it here.

How did I become involved with Transition Minch? Sue Edgley and Mike Sheldon had some display boards at the Goodwill evening in 2008; they were sharing information about the Transition Initiative. I knew about it because of my environmental studies and I was concerned that our apparent needs and lifestyles were shaped by an economic system that requires us to consume because it has to grow.

However, thinking about this logically, in a finite world this is non-sustainable. To help resolve some of these issues at a local level, I find positively applying helpful ideas within the community a good way of bringing us together and doing something for the environment at the same time. Down-to-earth problem solving is a great antidote to lots of bad news about the state of our global commons and it has been heartening to see how many in the parish are also interested. We are very fortunate to live in this beautiful area and know that people are helping to improve resources for each other; isn't that inspiring!

Michelle Thomasson, 22.3.2010

Cheese from the Forest to the Cotswolds

My husband and I moved to this area in around 1979. We first moved to a cottage in Frampton Mansell, where we farmed in return for rent. My husband bought a Fordson Major tractor for £400 and a baler that we had saved up for. So he started doing contract baling, which is laughable now, when you see the type of kit that people have nowadays.

So, what attracted us to this area? We'd been living in the Forest of Dean for twenty five years, farming. We needed a bigger farm and Woefuldane Farm became available. It's twice the size of our other farm, although we did have a farm shop.

Socially, we've noticed massive differences between our life in the Forest of Dean and Minchinhampton. It's like another country. There seemed to be more people there who

were born and brought up over there. It feels like a more down-to-earth sort of place. Minchinhampton, I suppose, is a bit of both.

But, then again, having said that, our own children were also born and bred there so we felt very much more part of the community; we knew everybody else. We will probably never reproduce that here, although the shop is starting to make us feel a bit more involved. But if you don't have a child that you take into school every day you don't meet so many people.

Melissa Ravenhill, born 1953

From Besbury to Paris and back

I haven't lived in Minchinhampton all my life. I was actually born up north, near Manchester. When I was ten my dad got a job in Nailsworth, so we moved all the way down here.

My dad's job was with the electricity board; it was called the CEGB, but my grandmother accidentally told everybody he was working for the KGB, which is actually a Russian spy organisation, much more exciting than what he was actually doing!

The reason I eventually moved to Minch was that when my husband and I got married we went to live in Paris and Brussels. Whilst we were living over there we happened to come back and visit this area, and we noticed the house that we are living in now. It is just down the road from where my husband was a little boy, because he used to live in Besbury Park. And in fact, from our bedroom window, he can see his old bedroom window. He loved growing up there.

Katie Jarvis, born 1962

Settled at last

I live in France Lynch now but we lived in Bristol from when I was about two to three and a half.

We lived in a flat in the city, although I don't really remember it. My mum doesn't really talk about it because she didn't like it there.

When I was really young, from about six to about eighteen months, we lived with my aunty and cousin, because my mum and dad split up for a bit – but they're back together again now, of course. My dad needed to travel then and my mum needed to stay at home with us, so that's really why they were apart. It was all a bit complicated.

But then we lived in Nailsworth where I lived in about three different houses, and then I moved to France Lynch. I'm very happy there because we've got loads of our old stuff together again. We've been there now for about a year. And I really like Minchinhampton School and my friends.

Tabitha Windle-Hartshorn, born 2000

Down from the Midlands

When I was very young I lived in Leicester, but then we moved to Minchinhampton and since then I've lived in Minchinhampton. I was about one when we moved. My parents are not together. That's partly why they broke up, because my mum wanted to live somewhere else and so did my dad. Our reason for coming here was that my mum thought the schools around here were better than around Leicester. She didn't think I should grow up there. I'm not sure if she knew many people here before we moved down here, but I think she had friends here. I think she grew up in Leicester.

How do I get to school and clubs, well I walk to and from school because I live just down the road in Friday Street. I've also lived in two houses on Tetbury Street. There's my mum, me, my baby sister, who's just born, my step-dad and my little brother.

Kara Lowrie Plews, born 2000

A toddler from Sussex

I was born in 1952 but didn't move into Minchinhampton until I was two. I used to live in Worthing in Sussex.

I've been in full charge of Minchinhampton Youth Club for over thirty years, but before that, when the club opened in 1966, I was one of the original members.

Andrew Brooks, born 1952

Accepted by the 'locals'

Rees: The reason that we first moved to this area was through my work at the Midland Bank (now known as Cheltenham and Gloucester).

Peta: Yes; when we first moved to Beacon Park, as it was known then, our house was in the process of being built in Ricardo Road – by the Neet family, I think it was). We moved in to our house, at number 23, in around March 1964, next door to the Baxters. Actually, I was just a wee 18 month old baby when we moved from Cheltenham to Beacon Park. When we moved, there were only 5 bungalows built, and we lived in one of those whilst our house was built.

In those days Cambridge Way was not built, and of course the other estate up next to Dr Browns Road. On the right was the cricket field, sponsored by Bertie Pink. Barcelona Farm came a lot later, and the close on the left of Dr Browns Road, which used to be Mr Holloway's lovely house and huge garden.

Rees: I remember our first impression was of a very attractive town, but never-the-less, sleepy.

Not a bomb site – but Dr Brown's Close in 1974/5.

Peta: Ours was the first estate to be built, and there were people coming from outside – there was 'new blood' coming in to the town.

Rees: Yes, it seemed as though it was all happening at once, obviously it wasn't, but it was a fast progression; there was no hanging about. Everybody wanted to move into their houses because they were all coming to work here. Of course, it wasn't ideal if they hadn't got a house to live in, paying accommodation here as well as paying the rents, rates and licences wherever they'd come from – which was all over the globe, in some cases.

Peta: As far as the reaction from local people to us 'incomers' was concerned – well, there was always a bit of 'them and us'. I remember Mummy saying that same thing a little while back. She remembered talking to somebody in the village, and then they said, well you've been here for over forty years now – so you're local. So of course, you have to have lived in the village for many many years before you are accepted as a Minchinhampton person.

Rees: Well, in fact I'm not sure that I reach the fact that it was 'them and us'; I feel it was more a question of the personalities, I reckon, that came into the place. They were

all outward-going personalities who were never afraid to say 'Hello', 'Good morning' and such like... People coming in, like myself, we were more than happy to embrace Minchinhampton, as a community, but obviously, we were encroaching on their neighbourhood and they were always going to be a little bit reserved – to begin with anyway, so we were the ones that felt the need to give and to compromise.

For my part, I was elected to the Parish Council in about 1971, and seconded to sit on the Youth Club Management Committee. The club house has an extended addition with a skittle alley and furnished leisure area and bar facilities.

Another project that I was involved with whilst on the Parish Council was the building of the library, next to the primary school, as well as the Porch Room attached to the west end of the church.

I retired from the Parish Council in 1978 when my job took me to Yorkshire.

In my patch as a Parish Councillor, there must have been about two to three thousand people. But then, of course, there are the commons of Minchinhampton, Bownham and Besbury, as well as Minchinhampton itself. It included Amberley, but not Brimscombe; that's a completely different parish. I'm not sure about Burleigh because boundaries have changed at various points in time. The Boundaries Commission controls all of that because it takes into account numbers of voters and so on.

When you think that there was a whole stream of house building around the 1960s and 70s, over 200 private houses were built. And then there was the local authority housing added on to the Glebe Estate, built at around that time as well.

Thinking about Dr Brown's Road, Dr Bright came to live in Dr Brown's house when he passed away, then there were the new houses built over the old cricket ground, around Dr Brown's Close. That was in the late 1970s.

Peta Bunbury and Rees Mills, born 1967 & 1929

Personal Profile and Thoughts on Joining Transition Minch

I moved to this area in 1995 when my husband retired from his job.

I was employed as a business manager with the local area NHS, responsible for all of the support services, based in Stroud but covering a large area from Berkeley up to Gloucester and right round to the Forest of Dean. So I was in charge of the porters, the catering, the cleaners, laundry and the accommodation services. All of the infrastructure, yes, and trying to save money – that was the big thing in my role at that time.

When we first looked at this area, with a view to settling here, we drew up a checklist, my husband and I, of what the town or village had to have in terms of suitability. It had to be near Stroud, of course, because that was where my office was, and, because we weren't planning on moving again. It had to have everything available in the town if ever the situation arose where we were no longer mobile. So it had to have bus services to the nearest little towns but also the infrastructure that allowed us to access support services close by.

Minchinhampton and Painswick both fitted the criteria, although in Painswick we didn't like the main road going through the middle of the town. So, in the end Minchinhampton met our requirements.

We had met people in Minchinhampton before we moved here, but that wasn't the thing that first impressed me at that stage. It was what was here rather than who was here. We found the house and we fell in love with it, and we fell in love with Minchinhampton, despite first visiting on a cold wet day.

Linda Nicholls

This was where I wanted to be

I was born in 1952, in Essex. My parents moved to this area in 1968, when I was 16. At that time I began my apprenticeship as an engineer in the Merchant Navy, so I was away a lot for the next 8 years, but Horsley definitely became 'home'. My parents ran the post office and shop in Horsley, retiring to Bisley in 1975.

After I left the Merchant Navy in 1976, I decided that this was where I wanted to be, buying my first house in Valley View Road Stroud, in 1976, marrying Fanny in 1977 at Stroud Registry office. We moved to Avening in 1979, and then here, in 1984.

When I first left the Merchant Navy I worked for an engineering firm for a couple of years, doing nine until five, Monday to Friday, and it just drove me mad, really. I think I wasn't happy with them and they weren't happy with me.

What do I like or dislike about Minchinhampton? Well, there's nothing I really dislike about it. Although if there's one thing I do dislike it's the way that occasionally people who are indigenous to Minchinhampton, or even some of the newcomers too, can be very dismissive of a new person who moves in and who doesn't quite fit the Minchinhampton mould. They can be a little obstructive, if you like. But we wouldn't have stayed here all this time if we didn't like it so much.

Mick Wright, born 1950s

Mum still keeps in touch with old friends

Rachel: We did live in Somerset before we came here.

Henry: Yes, but we lived in Brimscombe for 6 months, before we came here in February 1996.
Holcombe in Somerset is just a small village, not far from Midsomer Norton.

Rachel: We do go back there sometimes but I don't really remember it. I'd say Holcombe is quite similar in many ways – similar population, it has a post office and so on, but it is more spread out than Minchinhampton.

Henry: Mum's best friend still lives there and they keep in touch.

Rachel, Henry, Roger and Howard Auster, born 1989, 1990, 1993 and 1995

I really like my little stone cottage

I have lived in Minchinhampton for six years now, and compared with other places, well it's quite different in some ways and the same in others. I really like the house I live in, it's a little stone cottage. Minchinhampton is a very friendly place but also the people do keep to themselves a bit as well. My occupation, well, I run a therapy and healing practice and I also help to run Transition Minch.

Sue Edgley

Hong Kong was very different to here

Danny: Me and my sister, Abigail, have just joined. We came from Hong Kong because our mum and dad split up. The rest of our family is in England.

Abigail: We lived there for about eight years but came here for holidays and to visit family. Hong Kong was very different to here. It had lots of very tall buildings. We like it around here – it's quieter, and the people are more friendly. It was quite hard to fit in to begin with. I'm in year 5 at school and Danny's in year 3. Our dad works as a builder and our mum is a teacher. We've got a step-sister, but she's far away; I don't know where she lives, she's 14.

I like my teachers in school; Mrs Smith is my main teacher and I have Mrs Bridle for Maths and English.

Danny and Abigail Grant

We lived in the Crown

As a child, I lived in the Crown Hotel in Minchinhampton for a while, but I wasn't born in Minchinhampton. I was actually born in Cambridge; my parents had a pub there, but after about a year we moved to the Crown in Minchinhampton.

It wasn't a hotel then; it was just called The Crown. It was simply a public house, and in fact it was very similar to how it is today, except that where you go into the lounge bar and restaurant now; it used to be our dining room. And at the back, where there are French windows going into a little garden, we used to have just a window that we used to climb through to get in. I guess we must have lived at the Crown for about four years. Then mum and I moved to Rodborough, so we stayed fairly local, but lived in a boring old house, then. This was really hard actually, going from being in an environment of noise. I remember people would sometimes come upstairs, if they'd won a darts tournament, and leave various gifts for me, like bubble bath and so on. I had a nanny who lived upstairs with me, because my mum was a full-time publican and barmaid.

Sally Lewis, born 1970s

From the other side of the river

I have spent the majority of my life, until I was 19, living on the other side of the river, towards Ross-on-Wye.

As for comparisons; it was quite different because it was a very small village where I didn't know anybody, because they were all elderly. Minchinhampton, I guess, you could sort of say the same, although I must admit I don't really know many people in Minch yet, apart from customers of course.

Special memories I have of my schooling. Well, the school I went to was Minsterworth. It was quite nice because there were just twenty of us; I still keep in touch with some of my old school friends and it was just nice being in a little community school like that.

I still hang out with one of them, I saw him last Friday night. I do have my own transport; it rarely works, but yes, I do have my own car.

As far as secondary school was concerned, my mum took me to primary school but I caught the school bus to secondary school, Newent Community School, much the same as they do around here.

As far as more studying, well I did a four year engineering HND, studying away from home; it was based in Bath, but it wasn't uni. I was working and living with my girlfriend in Gloucester at the time. It was a mix of work and student life which was quite nice.

I kind of liked it but I have two massive bedrooms living here at home on my parents' farm. I don't have to pay much rent, so that's far more appealing than living on my own. I can still enjoy a good social life with my friends as well. I can have all my friends round here on a Saturday night if needs be.

Henry Ravenhill, born 1985

The Commons

The changing use of the commons around Minchinhampton

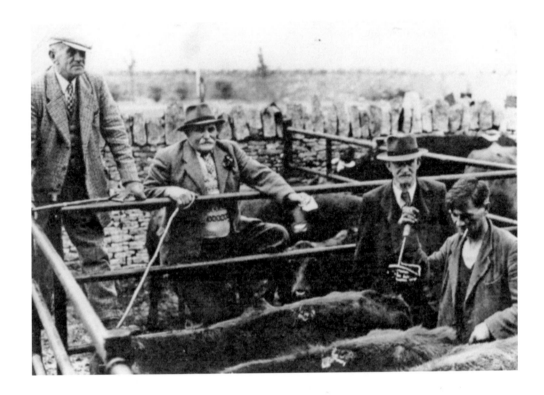

Commoners' rights in the ancient parish of Minchinhampton

'Commoners' are those people who own a property that was registered under the Commons Registration Act in 1965. Commoners have the legal right to turn animals out for grazing on Minchinhampton Common.

The general public is very good when it comes to reporting sick animals

We only put young stock out because the milking cows stay at home, of course. I mean, we put the young stock out, male and female, when they're one or two years old. We also have young heifers out there on the Common with young calves ready to be born. After they've come off in the autumn, they'll have the calves after Christmas.

We occasionally have things like New Forest Eye which is an infection which either has to be treated on the Common, or you have to take them off and treat them. As far as regular checks are concerned, the hay ward keeps an eye on them and we, as commoners, keep an eye out for each other's cows. They each have an ear tag which is coloured according to who owns them. Ours have red tags, someone else's are yellow and some are white. And, of course, if we or the general public see an animal that is injured, then Mark Dawkins will be contacted immediately. The general public is very good when it comes to reporting sick animals because of course they don't like to see them suffering.

The commons are a very large area of course, so sometimes you can't find an animal for days if it's down amongst the trees on the slopes.

We had one calf that had sustained a nasty gash in its leg, one year; a member of the public informed Mark. It took a while to find it, but we took it home, treated it and it's fine now. We're members of the Minchinhampton Commons Committee. We have grazing rights which come with the deeds of the farm. This means that we have 25 adult grazing rights.

Melissa Ravenhill, born 1953

A cow kicking incident...

Stroud News and Journal, October 2009.

Dozy in May

As far as turning the cows out onto the Common each May; we've only been here in Minchinhampton for a few years and we thought that they'd go wild when they were first released, but actually they're quite dozy. If anything it really calms them down. I mean our cows are quite calm anyway because they are handled a lot anyway. We've only lost one cow on Minchinhampton Common this year. On the second day after they were put out in May, one was run over and killed, but since then it hasn't been a problem.

MY MEETING OF TOM LONG

One cold dark misty night I was walking past Tom Long's post when I thought I heard someone say, "Stand and deliver", but I knew I must be hearing things because people didn't say that for real any longer so I went on walking. A few minutes later I heard it again. "Stand and Deliver". This time I looked round but I couldn't see anyone so I went on walking. Then for the third time I heard the voice "Stand and Deliver", I looked round and saw a white figure coming towards me. Then I remembered where I was. Tom Long's Post of course — this must be the ghost of Tom Long himself. I decided not to be silly and run away from him but to be sensible and ask him what he was doing. He said that he was haunting around here to make sure no one took his post away. Then I decided to get on home. The next morning I came back but he would only speak — he would not show himself because it was light. He was talking to me about his life and how he had been a Highway Man. Then his voice disappeared a van drove up and took away the post to put a more modern one up, so they took it away. The next night I came up again and called for him but there was no answer. I came back many times again but I never got an answer again after that post had been taken away.

About a year after that dreadful mishap to Tom Long I was walking by Tom Long's post when suddenly I noticed that the old post was back except that it had been cleaned and painted. Then I saw him the one and only TOM LONG but this time he was dressed up in a nice dinner suit. I asked him why he was dressed up like that, he said he was having a party with himself to welcome back his old post. He asked me if I would like to join in so I said yes and said I would go home and fetch the balloons left over from my brother's party two weeks ago. At 11.00 clock I went home. Tommy was drunk with too much cider. I didn't like it so I drunk orange squash all night. The next day I went to see if he was all right. I came just in time because he was holding himself down by the post. He said that the gas in the fizz had made him go all funny. Finally he let go and I watched him float slowly up to the spirit world and he was never seen again.

HELEN LISTER

... from an essay competition in Minchinhampton School, March 1977.

Observations on Minchinhampton Common

Early one morning in May – great excitement,
'The cows are back, the cows are back!'
Rapturous bellowing in the distance and the sight
of many cattle littering the horizon,; following
the muddy paths, and grasping with their tongues
the yellow carpet of dandelions and buttercups.

The blue haze on distant hills; the gentle
shimmer of the River Severn; and friendly
top-hatted May Hill, watching over the
Forest of Dean.

The pungent smell of springtime wild
garlic on the woodland slopes around
Minchinhampton Common.

Minchinhampton is a unique place; tranquil
early in the morning before the cars stir
from their driveways.
The sound of skylarks fills the air from
Spring to Autumn; a lone green woodpecker
squawks loudly as it darts past; a colourful
kestrel hovers above the road on silent
wings, hoping to catch a mouse or shrew.

Well-toned, lycra-clad joggers rush past,
clutching their water bottle in one hand, IPod
in the other.
Parents appear, shepherding their children into
Minchinhampton School, some by car, some on
foot. Sometimes a year 5 or 6 pupil races past
on their bicycle, late for morning registration.

And dog walkers like me; or great packs of
pedigree dogs, Springer Spaniels or
Labradors, on an assortment of leads,
followed by their professional breeders.

Down by the Bulwarks, two horses amble
past with their jodhpur wearing, fluorescent
bibbed riders, chatting amiably to one another.

Nurses from the nearby Cotswold Care
Hospice or Horsfall House enjoy a sandwich

and some fresh air on the Great Park
before returning to their duties.
The keepers of the golf greens clear
away the big steaming pats left by the
cows the night before.

Up beside Tom Longs Post and the reservoir
it can get pretty windy. The kite flying
families come out to play, admiring the stunts
of the larger kites and the buzzing remote
controlled aeroplanes. High above the treetops
a bi-plane hums and roars as it performs
acrobatics, perhaps practicing for Kemble
or Fairford. It is joined the gliders from
Aston Down as they swoop and sway, riding
the thermals.

Families and friends queue patiently at
Winstones ice cream parlour. Above
Pinfarthings and Amberley School the
panorama of Woodchester Park and the
windmill at Nymphsfield.
From Stroud, down in the valley, comes the
sound of churchbells. The wind changes direction
and all of a sudden a cacophony of clanging as
the bells at Minchinhampton Church are being
rung up ready for a wedding.

Young boys meet next to the alpacas to ride
the bumps on their bicycles, or to share a bag
of sweets purchased from the 'Happy Shopper'
in town.

Once every two years the peaceful nature of
Minchinhampton changes. Colourful caravans
appear overnight inscribed with the words
'Giffords Circus'. Next to the churchyard a
circle is formed where raggedy children play
with their dogs; a couple of horses, the sound
of geese and muffled drumming as the
performers rehearse their moves ready for the
show. In the evening champagne corks pop and fizz
as the guests enjoy a short picnic during the interval.

On Dr Brown's Road a small family of Highland
Cattle gather expectantly around their commoner

owner as he unloads a large bale of hay from
the back of his Land-Rover.
A neat line of little fluorescent jackets as Mrs Tomlinson
leads her nursery group along towards
the rugby field; stopping briefly to pick a dandelion
or admire a passing butterfly.

Loudspeakers in the distance announce the
beginning of Gatcombe Horse Trials, or perhaps
today it is the Beaudesert School Sports Day.
A gaggle of strolling nature enthusiasts from the
Minchinhampton Walking and Wildlife Club chatter
excitedly when they spot a buzzard flying above
Iron Mills Wood.

Cubs shout raucously as to each other as
they run, jump and bump into each other,
...'Who will be the winners?'

A warm summer's evening, hazy sunshine,
the smell of freshly cut hay. Some mysterious
huffing noises overhead and a dozen hot-air
balloons drift languorously into sight, on
their way to wherever the breeze decides
to take them.

Dusk. Every now and then a single car
interrupts the silence. The lonely high
pitched bark of a fox as it trots hesitantly
across the Cirencester Road. Pipistrelle bats
dart past on fluttering wings as the universe
gradually appears through the light blue haze;
a myriad of tiny flickering dots.
Mysterious lumbering shapes approach,
heavy breathing, a tearing, ripping sound as
the cows wander past nonchalantly, heading
for the shelter of the trees. The rain is coming.

Maureen Reader, 2010

Minchinhampton Common – September 2009

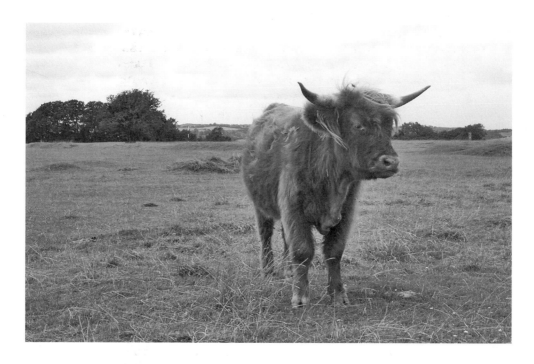

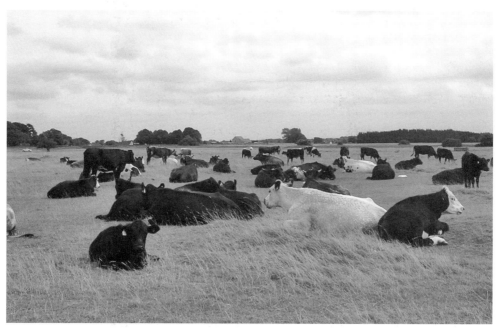

Cows relaxing on Minchinhampton Common, with Atkins Alpacas in the background.

Winstone's ice cream van, 2009.

Looking down towards Woodchester Park.

Looking down the valley towards Gatcombe Park.

Above: A view across Minchinhampton Common towards the Old Lodge.
Right: On the 'old' golf course, near the Old Lodge pub.

A winter's scene: beyond the cattle trough looking towards the old rugby field.

Following the ridge of the 'Bulwarks' towards Tom Long's Post.

Home Life, Health and Employment

Games in the dark...

When we were kids, in the 1940s, we played hare and hounds on the Common, even in winter. One of us would go ahead while the others had their eyes shut. The first person would leave a trail of sticks, in the dark, then after counting to 50 the others had to find him.

We would spend hours out on our bikes or just playing in the garden on our own, that's if our mum hadn't given us household chores to do.

We had a wet fish shop in the High Street. This was in the 1940s, and around Christmas time people used to bring their birds for plucking in the shop.

Billy Waldren used to come round with the milk churn, after the war. He would ladle it straight into our jugs. We used to go 'scrogging' for apples in the autumn; we collected field mushrooms off the Common and, of course, loads of blackberries.

Colin Shellard, born 1940s

Health Matters

Our doctor was Dr Brown; he brought me into the world and gave me my name. He was here all his life, I think. He was up on Dr Brown's Road, and we had to pay to go to the doctor in those days; the National Health Service hadn't started up at that time. If you were put on the panel or had a sick note to take to work, you'd have to pay a shilling. *(Dan) 'I know a girl who lives in Dr Brown's house'.*

Yes, we used to have to walk all the way up Dr Brown's drive to get to the surgery. His house was the only house there. This was before Dr Brown's Road, the Scout Hut and all the new houses were built, in the 1950s and 60s, I think. It was just a little lane with no name before then, and fields.

There was a school dentist as well, and the school nurse used to check our hair regularly for head lice, something I know your mums have to do now. People's teeth are certainly much better now than they used to be.

I was a nurse at Stroud Hospital before I got married. Healthcare is much better than it used to be. We do enjoy much better health now, children are vaccinated against killer diseases and there are much better treatments around now. We eat healthier, on the whole, and we have more doctors in Minchinhampton now, to look after us when we're ill, and better qualified nurses, of course. And we mustn't forget that life expectancy in the 1930s was much shorter than it is today – probably about 50-55 years.

Care for the elderly in Minchinhampton is much better now. There didn't used to be nursing homes like Horsefall House and Cecily Court. I know still a lot are left in the care of their families, but they have done a lot to help people that are on their own.

Poppy Cooke, born 1926

Dr Brown was lovely – a plain man to look at. He must have been owed thousands of pounds in money. There was no National Health, but he still treated people, and very often he wouldn't even send the bill. He lived at the top of Tetbury Street, and had his surgery in a kind of a garage before he moved to Dr Brown's Road.

A tribute to a much loved family GP who served the community until the mid-1900s.

Starting work at a young age

How would you feel about going out to work at the age of 14?

Warmth from an old bread oven

We didn't have central heating in our home, but a coal fire. Our house was built in the 1930s. It looked a bit like a Victorian house, but it had a beautiful bread oven, heated by a coal fire, in one of the rooms, which helped to heat the hot water.

In terms of communications; when I was small we didn't have a telephone, we had to borrow the neighbours'. We did have a television, and my mum had an automatic washing machine – it was a twin tub, which meant that she had to lift the washing over to the other side to spin it dry. She also had the old-fashioned mangle, which she would use sometimes for the big sheets on wash day.

Michelle Thomasson

Katie Jarvis chats in school with the Time Detectives

When I was little my mum couldn't drive, so of course she didn't have a car, although dad had one, so we walked everywhere. When I was eight, though, she passed her driving test and I remember feeling petrified every time she drove us because I just wasn't used to her driving.

Of course this meant that we didn't have to walk down to the shop every day or two to get food. The car suddenly allowed us to really stock up on food, even though there weren't the big supermarkets that we have these days. Tesco and Sainsbury's came later, of course, and also the variety of foods and other products that we take so much for granted today.

Another thing I remember is that mum had no washing machine; there were no ready meals to make life easier. As I said, the boiler had to be fed with coal to provide hot water. Because these things were harder, children would only have a bath once a week – not my generation, you understand, but in earlier times.

Jack: Cool! (Pupil's comment)

Another thing; a number of years before I was born, laundry would have only been done on a Monday; the whole of the day would have been wash day. So although it was hard work, they didn't do things as often as we do these days, so it was probably about the same. Maybe they were less fussy or maybe more careful with their clothes – I don't know.

Andrew: Does that mean they didn't go to school on Mondays?

No, certainly not when I was little, the children didn't help with that sort of thing. Having said that, fifty years before my own childhood it was different. The children would sometimes stay home to help, especially in the summer when there was a harvest to bring in.

Phoenix: Did you go to school on a Saturday or Sunday?

Well, when I lived in France, which was when I was about eight, I had to go into school on a Saturday morning, but not on a Wednesday.

When I was at school in France, a few years back, they kept swapping me around classes, to test me out. The trouble was that half the time I didn't know what they were saying!

My mum didn't work until I was about fourteen, and I can certainly remember when my little brother was born. He's about three years younger than me. She used to have to wash all his nappies by hand – that couldn't have been a great job.

I remember, also, the boiler that gave us all our hot water had to have coal put into it, which was a very messy business, and carrying coal in from the coal bunker at the back of the house was hard work as well.

Now, moving on to stories about Minchinhampton that I have come across as a writer.

Well, I've thought about lots, but one story is set during the war when children, as you know, were evacuated from cities like London to places like Minchinhampton, because they were a lot safer, weren't they.

There was a gentleman called Stan Vick and his wife May, who lived in Tetbury Street, and they took one of these London children into their home. Well, when Stan was in his garden digging up vegetables to eat for dinner, this little boy from London watched

him and said, 'Why do you keep your vegetables in the ground?' He didn't understand that they grew there, because he had never seen vegetables growing. He thought it was a sort of cupboard!

Another thing I remember from my childhood is that we'd have a man coming down the road with a pony and cart, and he'd shout, 'Rag ... bone, rag ... bone'. This was the rag and bone man, and people would bring out their old clothes and any pictures they didn't like, and all kinds of rubbish – but not quite rubbish, if you know what I mean. He would sort it all out and then sell it on. I don't suppose he was very rich. People would also run out into the road with a spade, after he'd gone, and collect any horse manure left behind, to put on their roses or vegetables.

And finally, another story that made me smile was this one; a few years ago it wasn't as easy to get hold of a doctor as it is today, and people had their own special remedies. Well, one lady told me what her mum used to sprinkle on milk. Would you believe it – gunpowder! The stuff that fireworks are made of. She used to buy it from the chemist and people actually believed it purified the blood! And they used to believe that smoking used to stop you catching diseases!

Do we agree with that nowadays?

Phoenix: No, it causes diseases! I wish we could go back in time and talk with them. We could tell them it's wrong!

Questions to ask

To the time detectives

After talking to your parents, how do you think your childhood is different to theirs?

Would you have liked to have been a child 50 or 60 years ago?

To Mums and Dads

What special memories do you have of your home life when you were a child? Share these with your own children.

Where many a youngster was sent to work – Longfords Mill

Woollen cloth was manufactured here for over 200 years by several generations of the Playne family. The mill closed in 1990. Gatcombe Lake above the mill provided a regular supply of water.

Many people worked at the mill, coming from Minchinhampton, Avening, Nailsworth and Box, most people starting their working life there from the age of 14 or 15. 'I went to Central School until I was fourteen-and-a-half. Then I started working at Longfords, in the office. My job was to run around and do book-keeping. My hours were 8 a.m. until 5.30 p.m., and I got 10s.'

A cow in the bunker

Of course, Mondays were always wash day, which meant that it was often something simple like bubble-and-squeak for tea.

I remember the winter of 1962-1963. I was working as an apprentice plumber for Coopers, the builders, in Burleigh. My Dad had worked as a sawyer at Woodchester saw mills for 42 years, from the age of 13. He said to me that from the age of 13 he'd be getting up at 6 o'clock in the morning, to walk across the Common in the pitch dark, and sometimes he'd perhaps almost walk into a cow in the bunkers. It's amazing how you can hear the cows from quite a distance by the sound of munching and breathing. He then spent the last ten years of his working life as a builder. In those days my Mum worked at Houghton and Neville's, the chemist in the High Street. She would cycle across the Common with me to school, work there in the morning, and then go to another cleaning job in the afternoon. Most Mums I knew seemed to work part-time.

We used to entertain ourselves, as children. I remember once, when I was in my early teens, we went on a bicycle ride to Tetbury. I remember one of us, Michael Cott, I think it was, had a puncture. We took it into the garage and the garage owner stripped the wheel out, mended the puncture and we were on our way again. It's not the kind of service you'd expect these days, I guess.

As children we would also play 'Tinayacky' up on the Common down on Besbury banks. One boy would be on a base and he would have to come out and catch the others. The idea was that the first boy to be caught would have to run back to the base, kick the tin that was the base, and shout, 'Tin ay acky!' I know the cubs still play this game even now, although they don't call it Tinayacky.

Other members of my family; well, my granddad, (Mum's dad), lived in Thrupp. His wife died when my mum was only eight. He eventually re-married and moved to Wales; a little place called Aberkenfig near Bridgend, where he worked in the coal mines. He lived into his early nineties and never came back here. I remember going to visit him there just after the Severn Bridge was built, in the early 1960s, just after I passed my driving test.

John Bingle, born 1945

Why are there huge holes on Minchinhampton Common?

Many of the holes on Minchinhampton Common are due to the quarrying of stone for building work. The type of stone quarried in Minchinhampton up until the end of the twentieth century was Great Oolite; full of sea shells some 4-5cm in diameter. The best type of stone for building did not have the fossils in. Timbered cranes and winches were used until the National Trust installed a steel jib crane. The blocks were then loaded onto trucks and taken by steam traction engines to Stroud station for transport by rail.

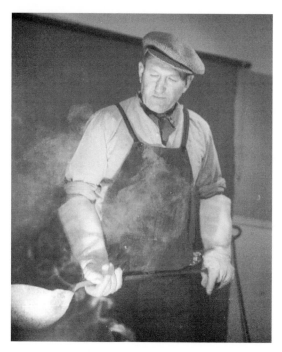

The local blacksmith.

And why are there tunnels under Minchinhampton?

There is also an underground tunnel at Ball's Green that runs under the village of Box. The stone from the Simmonds' quarries has been used to build parts of Minchinhampton Church, Cotswold Chine, many houses in Minchinhampton and Box as well as Maisemore Bridge over the river Severn.

There are also some very important archaeological structures called 'The Bulwarks'.

What my Mum and Dad do

My mum works at Mrs Tomlinson's nursery at the Scout Hut on Dr Brown's Road, and my dad works for Wyatt Fuel Services in Stroud. He does plumbing and engineering; in petrol stations he installs and unclogs fuel pipes and so on.

Liam

My family has been in Minchinhampton for generations

I'm Kieran Hart and I was born in 1998. I've lived in Minchinhampton all my life and most of my family live in this area as well. My gran and gramps live just down the road from here. I know my gran's mum's mum lived here, as well, but I don't know much

about her, except that her side of the family is called Wood. Fred Price, who works at M&B Stores, is my next door neighbour.

So, what do my parents do for a living? Well, my mum's been working at Horsfall House for about three years, looking after the old people. Before that, she worked in the Crown Inn for about five years. My dad works away a lot; drives a lorry all over Britain for Downton's.

I have really enjoyed the WI, my 15 years working in the library and also my time on the Parish Council

My husband's work brought us to Minchinhampton in September 1977. Apart from 3 years spent overseas, I had lived all my life up until then in the East Midlands.

When we first moved to Minchinhampton I did miss the very regular public transport and having a large city for shopping.

I have kept myself busy in the town and really enjoyed my 15 years working in the library and my time spent on the Parish Council.

When we first arrived, back in 1977, I joined the evening WI, which filled the Market House when they met! Then some older ladies who preferred to meet in the afternoon formed the Hampton WI which met in the Scout Hut, and that was also a full house at that time. This group still meets on the first Wednesday of each month. This is the Common Edge group which includes Box, Nailsworth, Woodchester, Rodborough, and until recently the Amberley group (they have now closed through lack of support).

As the years went by and the numbers started to decline, the evening meetings were held in the Porch Room next to the Church. This group was eventually disbanded and the Ladies Club was formed which still meets in the Porch Room on the second Monday of each month.

The WI still has quite a few outings each year, and we have sometimes joined up with Box to make up numbers. Box organised a trip to Monet's garden and also the Bayeux tapestry, and a few members and husbands went from Minchinhampton WI.

Our members are now mostly elderly, and as we meet in the afternoon, most younger women are either out at work or looking after young children.

Times have changed from the time when most women stayed at home, and we now find holding coffee mornings in the town for fund raising very difficult. We now hold just one fund raising event each year, during our August meeting, which everyone thoroughly enjoys.

We hope to carry on for a few more years, but we do need new and younger members.

Sue Smith, President of Minchinhampton WI

Let's share our memories

So as today's children come in from school, with history books in hand, get them to put their school bags down for just half an hour. Instead, take them onto your knee and weave them stories of your own childhood. Tell them the names of their great grandparents. Sing them the songs you used to sing. Explain to them about entertainment, before the days of television, computers and Gameboys.

It's your own history, and theirs too – individual history that belongs to no-one else but you. And if you don't pass it on, it will be lost forever among the winding streets and carriage wheels of yesteryear.

Katie Jarvis

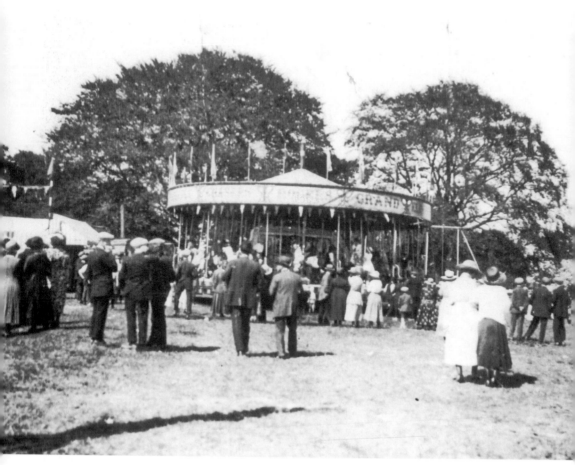

Spending time with the family – Roger's funfair on the common.

After school workshop – household chores

The Church in Minchinhampton

Some parting words from 'Father Michael'

The Rector writes...

As I have grown older, one thing that increasingly fascinates me about life is the concept of continuity and change. We only have to look at ourselves as the months and years go by - we are the same person but our physical body and, indeed, our emotional and spiritual bodies change over the years and decades. However, there is continuity in that we are the same person.

When I look at the history of our nation, and I am intrigued by that, there is continuity through the ages and, indeed, change through the ages. Sometimes it has been quite revolutionary change like the 17th Century during the time of the English Civil War, or in the life of the Church from the time of the first Apostles there has been continuity from one generation to another and yet truly remarkable change and changes. One hopes that a 4th Century Christian in modern day Turkey would recognise a 20th Century Christian in Africa or Asia, or even in Minchinhampton where there would be some real areas of recognition even though the outward and visible signs of those areas might be different.

As I come to the end of my time here as Rector of the Parish of Holy Trinity, Minchinhampton with St Barnabas, Box, I am aware that I have lived on a continuum of continuity and change. When I arrived I sought to build on the work of my predecessors, David Yerburgh, Michael Vooght, John Cornwall and Rex Hodson, and all of us, including the four I have just mentioned, would say that we have all sought to continue the work of the Apostolic Church down the centuries, and the one who comes to succeed me will be of that conviction too, I am sure. However, there will be changes, not necessarily great changes, but one that comes to mind is that Rex Hodson used to visit on a horse and that was quite normal in the middle of the last century. Minchinhampton has changed. When Canon Rex came here there was no Besbury Park, no Beacon Park, and no houses around the Dr Brown's Road and Close. The Christian faith is about living in the here and now but a continuum of what has gone before and what reaches out into the future and interpreting the Gospel afresh in every generation.

Michael Irving from Holy Trinity Church, on leaving in 2009.

It still has a place in the centre of the community

Moving on to my involvement in the church...

Minchinhampton Church hasn't changed much in recent years really. I'm not involved so much with Holy Trinity now, as I am curate in Brimscombe and Woodchester, but I do still go occasionally, and I celebrate communion on a weekday sometimes. Minchinhampton Church is not a great church for change, which is probably why I felt I would like to go somewhere else. The strengths of the church are that it is Eucharistic – it has daily communion, and it has a place in the centre of the community. I particularly like the way that Minchinhampton Church has wonderfully blurred edges between it and the community, as it were. They also have a very good relationship with the Baptist Church as well.

I think that things will improve even more with Chris Collingwood, our new priest in charge. I think he's much more open than any rector I've seen here. He really makes the effort to engage with the Baptist Church, and also with other faiths as well. I mean, even in Minchinhampton we've got Hindus and Buddhists. I know the children growing up in Minchinhampton don't come across other ethnic and faith groups as much as other towns, but it's better than it used to be, and of course they do have much more access to other communities, especially as they get older and do things further afield.

I think we all have a bit of racism in us really, we all treat people differently according to how they appear to us, in relation to our own background and experiences. It's a kind of protection really, I guess.

I think the church is still strong; it is still a powerhouse of prayer. The Baptist Church certainly attracts more of the younger generation. That's why I like Brimscombe and Woodchester, because it is more all-age. These churches have very good relationships with their schools and both churches are child-friendly. In Minchinhampton both the Baptist and the parish churches have always been strong.

Mick Wright, born 1950s

I felt really close to people in my village

Rachel: Another big person in our lives was Father Michael, Michael Irving. He was great. We were all involved in the church through the years.

Roger: Yes, when we were younger we did our stint in the choir, and other things.

Rachel: And if there was anything important going on in the town, he'd be at the door, taking an interest and helping.

Roger: Yes, he was very much a community person; it didn't matter if a particular person went to church or not, he would have the time of day for anyone in the village.

Henry: With the church youth group, we did things like Outward Bound weekends and dragon boat racing. That was great fun, and I felt really close to people in my village. I wasn't so keen on being in the choir, but it has really helped with my music.

Rachel: We enjoyed the music in the choir, and we had the string group as well, didn't we Roger. The Christmas carol service and the Christingle were especially lovely.

Henry: Of course, dad played the organ sometimes, and he had a very big part to play with the music scene in the area; he was head of music at Marling for a number of years, at Dean Close in Cheltenham and also where Howard was – at Pinewood. And for four years in Scotland as well – we very nearly lived there.

Roger: But back in Minchinhampton; we still do the odd jazz evening, as a family sometimes. In the past we've done orchestras and so on in the area, and I am now playing the violin in the Stroud Symphony Orchestra with Jonathon Trim, my brilliant violin teacher of almost 13 years, but obviously now that we're growing up and moving on, all of that is changing. We're becoming more independent now.

Rachel, Henry, Roger and Howard, born 1989, 1990, 1993 and 1995

Minchinhampton Baptist Church

Changing Rooms, Ground Force, Richard & Judy. It just seems as if the world is obsessed with the idea of a 'makeover'. I have a confession to make. Sometimes I walk up Tetbury Street and look at the building which is Minchinhampton Baptist Church (MBC) and think, 'If only we could have a "makeover"!' The problem is, we can't, because we have a 'listed building'. That prevents us from altering the (front) facade of the church and so it remains – dull, grey-ish and uninspiring to look at it. But, 'Hey!', what goes on inside is a different thing entirely.

At MBC we firmly believe that God is a God who loves us, who is willing to forgive us, and offers us a life filled with meaning and purpose through Jesus. I have a passion to communicate that message – and to do so in a way that is powerful, relevant and contemporary. This means that what takes place at the Baptist Church in Minchinhampton will make you think about **life in the real world** – 'where you're at', 'where you're going' and 'how you're going to bet there'.

We run a wide variety of activities in addition to our contemporary Sunday worship services – children's groups; youth activities; women's groups. We even organise events specifically for men. At MBC we are really looking forward to the Autumn term – a term that begins with the Country Fayre and will unfold in a very exciting way. We have given this term the title 'Focus on the Family'. Research from the USA shows that 'there is convincing evidence that the better our relationships are at home, the more effective we are in our careers. . . . The evidence is overwhelming that the family is the strength and foundation of society' (Zig Ziglar in *Homemade*, March 1989). That's why we are making the family our priority for the Autumn term. We are launching this new project at the Country Fayre – so keep an eye open!

How about making the family **your** priority this term? Why not sign up for one of our special 'Focus on the Family' events? You can find details of these from our 'Focus on the Family' stall at the Country Fayre.

Come and chat to us at our stall (where we will be raising funds for our local charities) and find out more about the exciting and important things Minchinhampton Baptist Church is organising this autumn.

Rev Alisdair Longwill

Autumn 2001.

Shop Talk

Shopping Memories

Do you have any special memories of going to the shops in Minchinhampton as a child? Which is your favourite?

I'll have a piece about that big, please...

The types of shops and other facilities that we had when I was growing up; well, we had two bakers that made their own bread, one in Tetbury Street and one where M&B Stores is now.

There was a big grocery store on the other side of the High Street and if you wanted sugar, tea or coffee, they'd measure it out for you into bags, nothing in there ready-made. Your bacon was cut for you and sliced how you like it. Cheese wasn't measured by weight, you'd just say, 'I'll have a piece about that big...' And our money was pounds, shillings and pence, of course.

There was also a petrol pump in the High Street, next to where The Kitchen is now, and you used to have to wind the handle to get the petrol into your car. I remember the shoe-menders in Tetbury Street, and there were a lot more shops in those days.

Poppy Cooke, born 1926

Going down to the Co-op

Now, we're talking about the 1950s and 60s here.

Peter Jones, he used to bone the meat and then slice it using the big wheel. He used to live in West End; his dad worked for Ernie Amore in the butchers there.

Even in those days it wasn't a continuous line of shops; no, there were houses in between. On the bottom there was Ogdens, which was a clothes shop and hardware; then you came up to Walkers Stores in the High Street, where Murrays estate agents is now. That was a general store. Next you had Harry Walker with his bike shop. There was a pump there where you could buy petrol, around the 1950s. I was just a young lad then. I can't remember how much the petrol was, probably a few shillings a gallon, but I remember he had a spotty dog that nearly bit me!

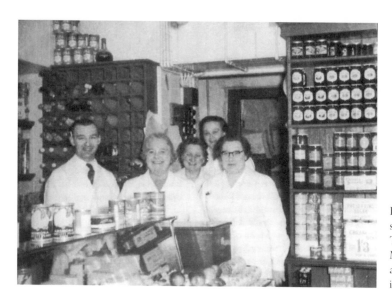

Bill Perrett, first hand shop assistant, Mrs Tombs, Mrs Dolly Messenger, Mrs Stone, and Georgie Edmunds, in the 1940s.

I remember when petrol was 35p a gallon, just around the time of decimalisation in the early 1970s.

Oh, and we had a blacksmiths opposite the old post office on Tetbury Street. Next to the old post office, of course, there was the Salutation Inn, where the electrical shop, FW Wall and Sons is now. There were 20 or so pubs in Minchinhampton then, weren't there? Yes, and then there was the men's club in the High Street. And I mean it was a men's club; no women were allowed in there at all. And I remember they used to queue to go in there, and once they were in there you never heard a squeak.

And when it was time for them to go home later that night they'd go home very quiet, and if they did make a noise Jack Simmonds used to tell them off! Yes, he owned part of the stonemason business in the town, up West End. There was a cafe called Arden House; I think they might have done square dances there. That was just up from Greylands where Lady Bevan lived.

There was the Co-op in West End. We had a 'divvy' of two shillings in the pound. You had a little 'chitty' with a number on it and, when you'd bought what you wanted the assistant wrote out the chitty so you got a discount on the price. Everything would be packed up in a brown paper parcel, tied up with string.

Colin Shellard, born 1940s

An early start

I started at Walkers Stores in 1928 when I was fourteen. The shop was very cold – there was no heating, or hot water, and just gas lighting. We had to start at half past eight in the morning, and I didn't normally finish until half past eight at night. That was six days a week and sometimes I also went in on a Sunday to help with stocktaking. I got

ten shillings a week. People brought orders in on pieces of paper, and the errand boys would deliver the goods on bicycles for free.

Pubs and Restaurants

Minchinhampton continues to have a useful range of shops and services, although in 1939 there were five inns in the town – the Crown, the Ram, the Salutation Inn, the Swan and the Trumpet. Now there is only one inn but a number of successful cafes and restaurants.

Shops on a Power-point

Di Wall, clerk to Minchinhampton parish Council discusses photographs from the past.

Well, we're looking at the picture of the inside of Taylor's butchers, of course. Taylor's was set up by a Mr Taylor, but he only had daughters and one of them married a Robinson. Mr Taylor lived over the shop in West End to begin with, but then moved to Tetbury Street and eventually passed the business on to Hughie and Steve. Mark, of course, tells the rest in his interview.

Another thing I'd like to say is that my husband and his brother have a shop in Minchinampton; it's the electrical and TV shop FW Wall & Sons. Before then it was The Salutation Inn. We know that this was a pub from 1695 until it closed in 1963.

My husband actually came to Minchinhampton School as well, but this was when it was the old Victorian building. Just out of interest, people in those days used to shorten the name Minchinhampton to Hampton, not Minch, as they do today. 'Hampton' means town and 'Minchin' means nun, from the Norman nunnery that was here at the time when the Normans took over this town in the thirteenth century.

You'll find, amongst the older people, they won't say Minch, like we do; they'll say Hampton.

On page 88 is Mrs Critchley's sweet shop and then Mr Hughes' grocery store is next door, both on the High Street. This was probably around the 1920s or 30s. The little boy standing there against the wall, Alan Hughes, he only died a couple of years ago; he lived in Butt Street.

Errand boys used to deliver on bicycles in those days, with great big bicycles on the front. Then there were paper boys delivering newspapers every day before they went to school. Even boys as young as 12 or 13 would be up at the crack of dawn to collect groceries or newspapers from the shops and deliver to the houses around Minchinhampton, even before they went to school.

There was a cafe across the road, where M&B Stores is now.

Phoenix: You can see the Crown Hotel up there.

Well yes, we know that the Crown Hotel has been around for hundreds of years.

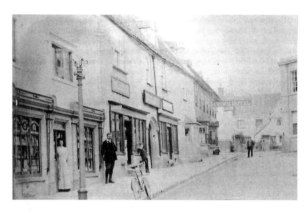

An early view of Minchinhampton's High Street, showing a sweet shop run by a Mrs Critchley.

Andrew: (Pointing to the area of the war memorial): How come the buildings are really high up there? Now it's lower down isn't it?

Ah, well those buildings are no longer there. They pulled them down in 1919 to put up the war memorial. It used to house a church club, a rifle range and public toilets. It was two narrow streets.

Then there was Walkers Stores, here is a picture of the inside of the shop.

As you can see, the shelves used to go all the way up to the ceiling and they had to climb a ladder to reach things on the top shelf. And another thing to remember, of course, is that things were always weighed out in pounds and ounces, not kilogrammes and grammes.

One of the ladies in this picture, Mrs Tombs, was married to the headteacher. Can you imagine seeing a headteacher's wife working in one of the shops in Minchinhampton nowadays?

And here is Georgie Edmunds, describing how it felt to be starting to work in the shop, full time, when she was just fourteen years old. Lovely lady Georgie, she's living in a nursing home in Tetbury now. In fact, Georgie Edmunds was one of the first ladies from around here to ride a motorcycle. She always had very powerful motorbikes. And later on, when she was shop manager, she would deliver with a sidecar attached to the motorbike. Ladies were driving cars, but a motorcycle was considered a bit too fast for them!

Georgie's salary was ten shillings a week, that's about fifty pence in today's money, of course. Which doesn't sound very much but then it would have bought a lot more in those days. Here, you can see the ten shilling note and the one pound note, something that we don't have any more. Now we have the new Stroud Pounds that you can change in the Post Office. I think Taylor's is the only place in Minchinhampton where you can spend it at the moment.

Another grocers shop was Hughes, next to the Crown Hotel. There was quite a lot of competition between the different grocer's shops then, just like you have between Tesco and Sainsbury's nowadays. Hughes used to say that he sold better stuff. They sold beers and wines, even then. It was thought that having an off-licence brought you up above the others. He also cured his own bacon and made it smoked or un-smoked. On the

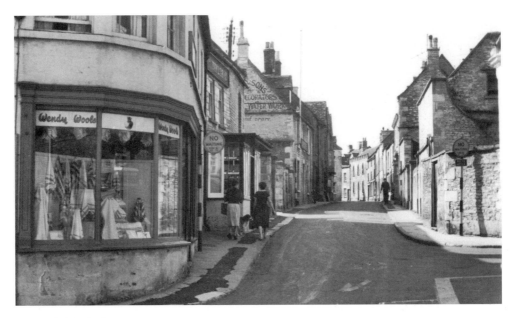

West End, Minchinhampton.

photograph you can see, look, European Wine Company; that certainly would have made him seem more up market, to have your wine from abroad.

Now, looking at where Boots is now that was Wendy's Wools, it was a kind of craft shop.

Maureen: Here is a photograph of a typical ironmonger's shop. Yes, this is very much like my dad's shop, when I was growing up in the 1960s. Everything packed into a tiny space, all sorts of useful items; from tools, screws, paints, paraffin and coal.

Yes, Brutons in Nailsworth used to look like that and, of course, the other hardware shop on the hill, the one with the big lock outside. But there was Walkers in Minchinhampton, before the 1920s that looked like that as well. This was not Walkers the grocers, but Walkers garage and ironmongers and you could buy all kinds of things there. A Mr Garmet ran it.

Phoenix: Did they sell Walkers crisps? They probably didn't have as many flavours as they have now, because they've brought out new flavours, when they had a vote.

Andrew: Yes, it was just about a year ago; now they have Builder's Breakfast, Bacon and Beans and Chocolate and Chilli. I can see Andrew Crook, 'a crook in your high street'...

Yes, he was a solicitor, as you can see from this advert from 1977, and then here's the Trumpet, that's still around of course, as are Taylor's and FA Wall. There's the Coffee Bean; that's the Kitchen now. You've also got Murrays; they sold clothes and wools. There's Vospers the antique dealers in the High Street; they were where Sophie's Restaurant is now.

Thinking about more recent housing developments, of course there's the area around Ricardo Road and Shepherd Way that used to be called Beacon Park. And more recently, Summersfield Drive, built in the late 1980s, and then Barcelona Drive built after 2000.

Phoenix: Yes, I live in Barcelona Drive. We only moved there when I was in year 2, about three years ago. My mum lived in the Crown Hotel when she was a little girl – oh, her name is Sally Lewis.

Yes, yours is the most recent development. Then we have the area around Cambridge Way, near the school.

Dan: Yes, I live around there on Grange Close.

People used to call that Cotswold Park, and so this brings us to the present day.

Minchinhampton Town Centre in 2010

A Taylor with fine cuts of meat

My great grandfather bought this shop in Minchinhampton in 1920; then my great uncle ran things until he retired in 1980, which is when I joined the business.

I worked with my uncle Hugh; he retired three years ago, which is when I was given sole rein. My uncle Steve actually retired quite recently. We also have Jack Clarke, a local lad who is now learning the trade.

As far as the range of meats that we sell; it's all sourced locally as much as possible. We have beef, pork and lamb from Gatcombe, we probably sell as many as 400 turkeys at Christmas: organic ones, free range, local farm ones and a few frozen, but the whole turkeys have dropped back a bit in recent years, and turkey butterflies have really taken off in their place. You simply get the turkey breast, no bone and no waste; people can simply carve pieces off when they need to. Whole pigs we sometimes sell as well, but trends in eating have really changed, of course; people prefer a much more highly trimmed cut of meat with a lot less fat.

Gone have the days when you'd cook a large joint of meat on Sunday and feed the family with it for the rest of the week. Of course, as local butchers, we can offer fresh game in season from the local estates. We sell ostrich steaks and ostrich eggs as well which are proving very popular. We have crocodile tails; they don't sell terribly well but they have a fishy, chicken flavour.

As far as deliveries are concerned we have a refrigerated van which delivers all over the Stroud area to hotels, restaurants, pubs and also a private delivery service. Fifty years ago, of course, deliveries were simply a boy on a bike with a large basket on the front. With a business like this that has been running for over eighty years, of course we've had our ups and downs but things are looking very good at the moment.

Mark Robinson, born 1970s

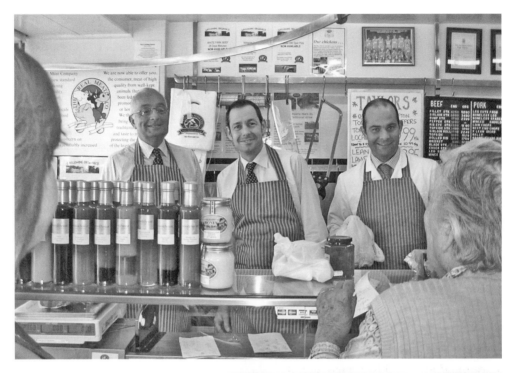

Taylor, the family butcher.

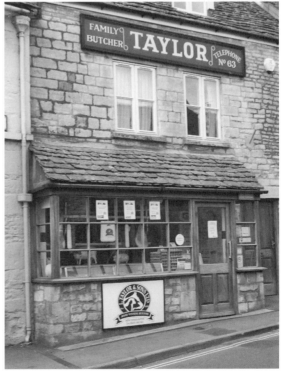

Stone by surname and stone by nature – the architect

The background on my becoming an architect was really my involvement within the building industry. I'm third generation of building in stone. Both of my grandfathers and my Dad were in the building industry, on the carpentry side, so it was a natural progression for me to have an involvement in some way in the building industry.

That, with my fascination for building things with Lego, Meccano and Plasticine, really made a logical link for how I could do something that ideally allows me to create something from nothing, and ideally leave something tangible when I've finished. And, after all, architecture is a superb way of doing that; to start from scratch with either nothing or a very simple concept, through to the completed building, and hopefully working for the client in a suitable fashion that they are happy with and that you can feel proud of.

I think as architects we are incredibly well placed to help people review their lifestyles. Not one solution will suit every house in the country. We all treat our properties in a different way, whether we are a family or single, whether we work from home, whether we cook with mainstream ovens or simply use a microwave. All of these things affect the way in which we expect our houses to respond, so there's a challenge there.

Chris Stone, Quadra BEC, born 1960s

A jug of something organic

Things are looking very promising for the cheese shop.

Funnily enough, our bank manager asked us why we weren't setting up shop in somewhere like Cirencester, but I think Minchinhampton is the right place. What we really want to do, without wanting to sound too altruistic, we want people to be able to afford local food with a very low carbon footprint, organic, because we think organic is healthier, and people in Minchinhampton really do appreciate this. We'd like to do this at a price that makes it accessible to people.

We don't want people to think we are elitist and charging silly money because we are organic. No, we've always farmed organically; it's the way we are.

The idea of having the steel jugs for dispensing milk is, of course, to reduce the need for plastic containers, but it is also a good memory jogger. Many people in Minchinhampton remember the olden days when milk was dispensed in this way.

I'd love to be able to go back in time to when Minchinhampton had its own dairy at Blueboys.

Melissa Ravenhill, Woefuldane Organic Dairy, born 1953

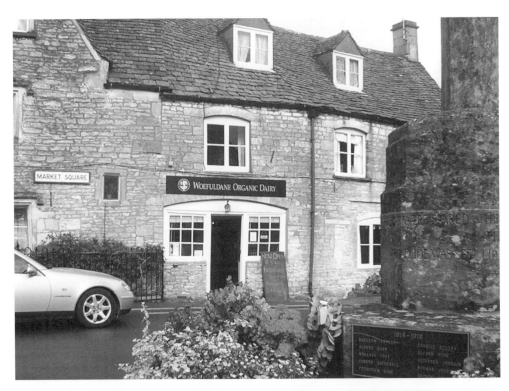

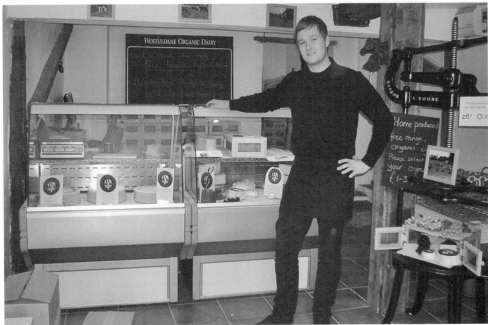

Henry Ravenhill in Woefuldane Organic Dairy.

Behind the scenes of Sophie's Restaurant

Our first restaurant in Minchinhampton was round the corner from here, where His & Hers is now. We moved into this premises in the High Street, six years ago.

As you can see, we store all of our wine and other bottled drinks down here.

Well, when we first moved here my husband, Mark, put up some shelves – they were full of apple juice. I was in the kitchen at the time. He came upstairs; then there was a huge, huge crash.

Everything was broken and there was a sea of broken glass and apple juice. Not a very good start to our new beginnings.

Apparently one of our girls had just come downstairs; she had taken just one small bag off the top shelf. She was lucky.

Well, of course, this is a very old building. Looking around the cellars here you can see a strange hole in the wall, that would have been where the coal was delivered, down the shute from the road.

So, now we're in the restaurant part itself. So, on the wall here is a portrait of my great great-grandfather, painted in around 1840, I would guess. He was French. Many of my relatives, of course, are still in France.

On the left we have the George Room. Now, this room we call the Book Room. Apparently that arch is there because originally, the little shop attached next door wasn't there, and this was a door into the side passageway where they used to take the horses – a long time ago, obviously.

Have I noticed any changes in people's tastes since I've been running the restaurants in Minchinhampton? Yes. I think people have become more adventurous. They get to know the types of dishes that I cook and are more willing to try something new. I think they're probably more adventurous, as well, if they are in a bigger group, and they tend to eat and drink more.

Now, this room is our little shop, Le Midi. We sell mainly wine in here. I'm half French, on my mother's side, so a lot of the cooking I do is French. We go to our house in France regularly, and we bring back wine from within 100 kilometres of our house – that's about 70 miles. So there are lots of different wine-growing regions. The pots over there – they come from a man, Monsieur Neu, and these special pots; here's a picture of the man that makes them, in a place near Toulouse. It's in a place where a dish called Cassoulet comes from.

Kara: My grandfather lives in Toulouse.

Oh, does he?

Kara: Yes, we go to visit him and grandma every year, in the summer holidays.

That's very interesting.

So, now, here in the kitchen we have the espresso machine, of course. And here I am going to show you how I make crème brûlée. But you'll have to stand right back because it can be dangerous. Here I use the blow torch to change the brown sugar on top – to make it crunchy.

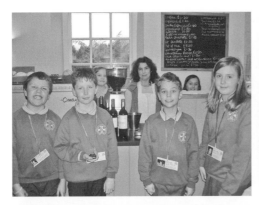

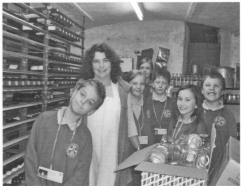

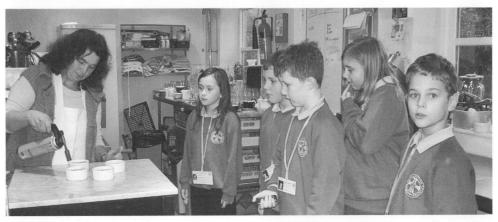

Behind the scenes of Sophie's Restaurant, November 2009.

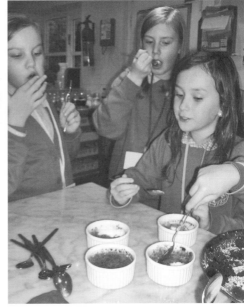

Dan: Ooh, I use one of these to make my dad do what I say!

Well, stand right back.

Tabitha: Mmmm, this tastes just like ice cream.

Yes, actually, it's made in a very similar way. And we make all of our own ice cream here as well – coffee, vanilla, apple; then we had damson, from when I had lots of damsons hanging around. I also do prune ice cream and, of course, chocolate. That's the ice cream machine there that I make it in. Other dishes, well, we do fish soup a lot, we bake our own bread and well, everything with a French, but also a local, twist.

It was a bit of a struggle to start with, but certainly worth it

I first became involved in the antiques business when we started doing markets and fairs, particularly Bermondsey Market in London, which I still did from here because we had a big mortgage to pay. It was a big step up from our small house in Avening; to setting up this antiques business in Minchinhampton. It was a bit of a struggle to start with, but certainly worth it. Our shop here, of course, was originally The Trumpet Inn. It had been a pub continuously for nearly 200 years, from the late eighteenth century until 1976. It was a private house for 8 years, before we bought it.

In terms of our business and the types of things that we sell, well that has changed a lot. Furniture doesn't sell as well as it did; particularly brown furniture. We tend to sell much more quirky things now, both furniture and all sorts, really.

The internet is useful to us. We have embraced this new market at our disposal. I mean, many people used to say that the antiques trade suffered because of the antiques fairs, but it wasn't a problem for the businesses that used them, and this is the same with the internet; you have to adapt and evolve.

My fondest memories are of the Vospers and how gracious they were when we moved in. They had the antiques business on the High Street, of course. They could have been quite hostile, thinking, well who's this moving in? They could have taken on an attitude about competition and so on, although I did already know them from around the auction sales. But actually, all three of them, John, Jim and Eric Vosper, became really good friends. We were never really in opposition because they had the manpower and the established reputation. They were more in the business of house clearances and handling larger quantities. We did different things, and there were things that I knew much more about. My expertise was in the smaller things, like clocks and watches, silver and gold. Jim was the youngest Vosper, the one I knew best. We were always sending people to each other if we didn't feel we had the goods, expertise or manpower to satisfy a customer. It was a very affable relationship.

Ours is the kind of business that can survive in a small town because it is not competitive. The more antique shops there are in one place, the more people come to that place to have a look around. Take Hay-on-Wye, for example, with its books. We provide a service with advice, and it is real recycling. It is certainly much better than a

Mick Wright's antiques shop.

big diesel lorry coming around once a fortnight picking up plastic bottles. That's not recycling – we do recycling all the time! It also teaches people to value the past and what was produced.

Mick Wright, born 1950s

We sell all sorts here

I've lived in Minchinhampton all my life – yes, sixty years. I started working in M&B Stores thirteen years ago. Brian over there has been involved in the shop for eighteen years.

It was Swans & Brothers before then, still a general store. As far as changes over the years, from selling shoelaces, lottery tickets, paying all your household bills – you can do it all in here.

Bread and cakes are the things that have really taken off in recent years, because there isn't a bakery here in Minch. We sell all sorts here. I mean if it didn't sell, then we wouldn't have it on the shelves – it's as easy as that.

As far as the supermarkets are concerned, well, in the first instance, we understand that this is a convenience store. What I mean by that is that it is convenient for you to

come in. Of course, you do most of your weekly shopping in the supermarket, and we do, but when you just want a packet of biscuits or a bottle of milk then you come in here. That's what we all rely on, and it's the same wherever you go.

There used to be Mr Butler down in the West End. He was more of a newsagent, selling newspapers; then he diversified a bit, for a while, and carried lines that we do, but that didn't seem to work. When he retired some Polish people took over the business, but that didn't last long, and now that shop has been standing empty for a number of years.

I think I'd rather live here than Tetbury; I worked there for eleven years. It's a funny place, Tetbury, ... Minchinhampton's a real mix of people, with the Glebe estate and so on.

Fred Price, born 1950

Taking over from the Salutation Inn

I have lived in Minchinhampton all my life. My dad is Frank Wall, the electrician, who started the electrical shop FA Walls and Sons in the 1960s. The two Walls that run the electrical shop are my brothers, Eric and Clive.

When my dad first came to Minch, he had what is now Julie's hairdressers, up in Tetbury Street, so that was his shop originally. Then he moved down to where they are now, which used to be a pub, The Salutation Inn.

I rent these premises from David and Barbara Boyd. They used to have a butcher's shop here. David is from London originally, of course. When he retired, a few years back, the shop first became a florists and then, just after the Goodwill Evening, around Christmas 2008, I decided to move my shop, Stafford Cottage, up here, from down in Thrupp.

I have been running Stafford Cottage now for over 7 years. Our most popular products; well, I sell all sorts really – clothes, bags, jewellery and other accessories. I get a whole range of ages coming in as well, from teenagers to elderly ladies.

Ruth Morris, born 1960s

My Mum had a room full of wigs

I remember, at the Crown, where the barn function room is now, my mum used to keep her horses in there. It was a proper stable. I guess in the olden days when it was a coaching inn, it would also have been used for the horses, and receiving deliveries from the brewery, I guess. We had our guard dogs as well, which we took with us to Rodborough when we left the pub. It felt very strange. As a child it seemed a huge place, with massive rooms upstairs, but of course now we go into the bar and it seems tiny.

I remember my mum's room up there had a little room going off from her bedroom, and this contained lots of wigs – she had a real thing about them, and hairpieces. It was great walking in there and seeing all these heads with wigs on them – the best place for a little child to be, trying them all on.

M & B Stores – Fred Price and Brian Arkwright.

Brookes Hair and Beauty shop display, 2009.

In my experience, Minchinhampton has always been a lovely community, with the cows wandering through the town in the summer. I remember when Sophie's Restaurant was Vosper's antiques, with Johnny Vosper standing outside being very grumpy. Going into his shop was a real treat – an Aladdin's cave of exciting things.

And there was David Boyd, when he ran the tiny butchers shop; he and Barbara are still around of course, and Ruth Morris now rents their shop for her clothes shop, Stafford Cottage. Dave used to sell a lot of vegetables in the shop as well, some of them probably from his allotment because I know he still keeps that up. They have got quite a big plot at the back of their house, as well.

Sally Lewis, born 1970s

Transport and Travel

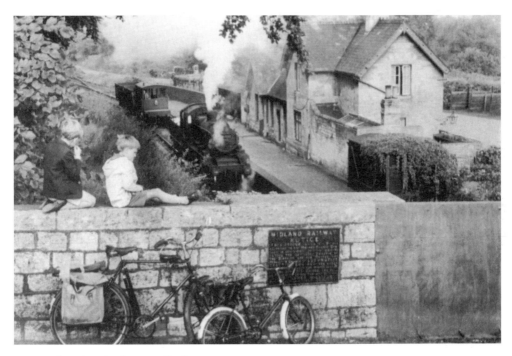

Boys on the railway bridge at Dudbridge, 1950s.

From Brimscombe Bridge Halt to Gloucester

As far as travel is concerned, my dad didn't have a car when we were growing up, and we didn't have a car until I learnt to drive as a seventeen year old, in the 1960s. This is when cars really took off for everybody. There were masses of cars on Minchinhampton Common, particularly on a Sunday afternoon when people would come down from the big towns for the day. Of course parking on the Common is restricted now, and people like to fly abroad, and so on.

We used to travel on the train from Brimscombe Bridge Halt to Gloucester and I remember being really excited about going on the train to Gloucester, to get a pair of Stanley Mathews football boots.

I also went on a trip, as a young lad, to see Wolverhampton Wanderers play football. My mum took me to Gloucester on the train on a Friday afternoon. We had a friend at

Kidderminster. He met me off the Midlands Red bus. I was about thirteen. He took me to watch Wolves versus Blackpool. I stayed there on the Friday and Saturday evening and remember virtually brushing shoulders with Stanley Mathews, as I walked past the players' entrance. He was famous even then and I've always supported Wolves since I was a youngster.

John Bingle, born 1945

Mainly on foot…

Our dad, the rector, had a car in the 1960s but the rest of us travelled mainly on foot.

I remember we once took the bus to Amberley, we were very excited! Our holidays were always in this country, mostly Minehead. Our annual Sunday school outing was always Weston-Super-Mare with fish and chips in Chipping Sodbury on the way home.

Like many other families in the 1960s and 70s, our mother did not drive, so we stayed mainly around Minchinhampton.

Angie Ayling née *Cornwall, born 1960s*

Increased travel and expectations

Another thing is that the world has grown smaller in terms of communications and travel; the expectations for young people being that they can make the most of it. It's really part and parcel of what we were dealt as children of the 60s and 70s, the expectation that we could achieve, and also the fact of Mums working as well, has meant that girls feel they can take for granted the same aspirations as boys.

Chris Stone, born 1960s

Car Problems

In the 1960s the car had become a huge problem on the Common. There were, as yet, no parking restrictions, and in August bank holiday, 1964, things came to a head.

The cheap air-package holiday was still a thing of the future and so when there was a nice day the Morris Minor, Mini and Beetle cars would bring families onto the Commons to enjoy a picnic.

The front page article in the *Stroud News and Journal* in August 1964 reported the impossibility of playing golf whilst 'cars and crowds took possession of Minchinhampton'. One person, a Commoner and member of the National Trust Local Management Committee, wrote in saying that he had counted more than 2,000 cars.

A Vospers delivery lorry on the High Street in the 1970s.

I could not wait to have my freedom

Henry: I was the first to pass my driving test in my year, so it was a big thing to have a car.

Rachel: There is so much more freedom with a car. If you want to go out for the day with your friends, or just to arrange something at the last minute, you can just jump in the car and go.

Henry: I like being able to go and watch Aston Villa, say, so I just drive down, meet up with a few mates in Birmingham, go and visit my girlfriend, or even travel to Devon!

Rachel and Henry Auster, born 1989 & 1990

Home Deliveries

Do you think it would be fun to have your groceries delivered by horse and cart?

Some questions for the Time Detectives:

- How do you get to school and to any clubs that you attend?
- What is your favourite form of transport and can you tell us about a special journey that you have made, perhaps abroad?
- What do you think of travel today; how do you think it could be improved?
- How do you think people might be travelling in years to come?

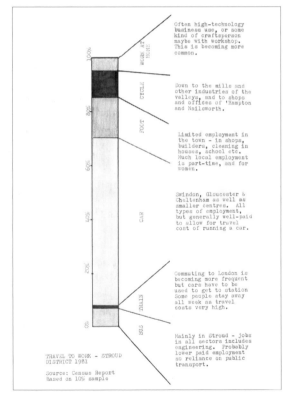

Travelling to work in 1981.

The Future of Travel around Minchinhampton

In recent years, increased concerns over the environmental impact, along with reduced consumer ability to pay for fuel for gasoline cars, has brought about renewed interest in electric cars, which are seen to be more environmentally friendly and cheaper to maintain and run. A number of them have even been seen around Minchinhampton.

A changing childhood

Most of the Youth Club children do come from Minchinhampton; but then again, going back thirty years the children would come from Stroud and all places. There was much better public transport serving Minchinhampton then and dads would also make time to bring them up. A lot of the time mums didn't drive.

Yes, when I was growing up here we would have a bus coming into Minchinhampton every 30 minutes.

And another thing is that children don't have the same sort of freedom I had when I was growing up. My parents would let me go and catch the train into Gloucester to watch the rugby. This would have been when I was maybe 13 or 14. I wouldn't let my children do this on their own; with friends perhaps, but not alone.

I didn't catch the train for school at Marling; I went on the bus, but I remember running down to the railway line, this was next to our school of course, and we would spot all the different numbers. That's something you don't get very much these days, kids train spotting.

We have been talking about how many more cars there are now compared to the 1950s and 60s; there's also the fact that in those days you could be reliant on all of the shops in Minchinhampton to fulfil your needs. Of course, now everybody goes to the supermarket and we all depend very heavily on our cars to go outside of Minchinhampton, to get whatever we want.

And the same is true of our young people and their social lives – a lot of things going on at the end of a car journey. They have wider experiences than we did as children, but not the same freedoms, not the same opportunities to learn self-reliance.

Andrew Brooks, born 1952

My favourite form of transport

Well, I know it causes a lot of pollution but my favourite form of transport is by plane because you get to get to see so many cool views and stuff.

Exciting places that I've been to, well, I've been to Portugal, Spain and Greece.

My favourite journey was Greece because it was really nice; the people are so friendly. My parents have been there a lot and we stay at the same place so we have got to know the people there. My parents only speak a little bit of Greek, just the basics, but that doesn't matter because the people there speak a little English anyway.

I like boats as well, although I've only been on a ferry on the Mersey.

I've got a bicycle, and me and my dad go for bike rides on the Common.

I think the way that transport could be improved would be if the scientists could develop more electric cars and give them out free to everyone! I know there are more electric cars in the cities. I've only been on a short train journey.

Of course, both my mum and dad have cars. My mum has to drive to work in Stroud. She works in a school there, in admin, in the Rosary Primary School.

We use our car for driving to the supermarket as well, but if we just need some eggs or something we usually walk down to the butchers. We live in Tetbury Street

so it's very close. We go to M&B Stores for bread and a newspaper and so on, if we run out.

Hannah Mason, born 1999

Air-lifted to Gloucester Hospital

I don't think I've ever lived in Minchinhampton, but I've lived in Hyde and now Brimscombe. I prefer old types of transport because I like the way they look, it's just that it's quite rare to see them around. Cars and buses.

A special journey, well, I've always liked going on trains, especially to London, so we catch the train from Stroud to Paddington. I've been to Oxford Street and, like, Westminster; I've seen the Houses of Parliament, but not been inside. I've also been on the London Eye; that was fun. I've been to the Aquarium and the Natural History Museum as well.

I've flown to Southern France, Spain and Italy. I've been on the ferry to France but I get sea-sick so I didn't like that. I've never been on the Euro-tunnel but that sounds like it might be fun.

An unusual journey I once made was when I was air-lifted to hospital when I was kicked by a horse in the middle of a field. This was in February, so it was a quick helicopter trip to Gloucester Hospital.

Flo Pond, born 1999

By Hannah Mason.

By Flo Pond.

A 'fab' Birthday in Greece

I lived in Bristol when I was about one year old, then I lived in Thrupp and I have lived in Minchinhampton since I was five. I think Thrupp and Minchinhampton are brilliant places and I have friends in both.

By Daniel Rock.

My favourite form of transport is by scooter, and I've probably travelled about twelve miles in one day once. Train journeys; I've been on tube trains lots of times across London, but I'm not sure where we went.

I've been on lots of holidays out of this country. We've been to France about five times and I had my birthday in Greece two times. There was this public swimming pool and my mum told the owners it was my birthday, so they set up decorations and lots of party stuff for me. We flew there but also went on a ferry to get there. We made sure we went on the boat at night because my little sister is terrified of water, and she feels really sea-sick whenever she's on a boat. I don't though, I love it.

Travel today, well, I like all types really, apart from cars, because I get car-sick.

Daniel Rock, born 2000

My taxi – Mum

I have only lived in Minchinhampton my whole life.

How do I get to school each day? Well, I sometimes walk, but my mum is working most of the time, so then she will drive me there, and to cubs, swimming, and Tai Kwando.

My favourite type of transport is trains mostly because I like going really fast on them and sticking my head out of the windows.

My funniest journey was when we went to the Scilly Isles on the ferry and everybody in my family was sea-sick, including me.

In future I would like to see lots more hover-crafts and flying cars, because travelling in ordinary cars can be quite boring.

Jack Stubbs, born 2000

By Andrew Reader.

Holidays with our dogs

Hello, I'm Andrew and I'm 9 years old. I was born in Stroud Hospital and I have lived in Minchinhampton all my life. I like living in Minchinhampton because it has a few little shops, cafes and the people are friendly.

My favourite form of transport is by boat, because, like, if it's really rough it's fun to go up on top of the ship. I'm lucky that I don't get sea-sick. A special journey that I've been to on a boat was when we went to Ireland. We had to drive through Wales to get to Fishguard; then we went on the boat to near Dublin. Then we had another drive all the way across Ireland to the west coast. Well, in the first week we stayed in a cottage near Dingle and then in the second week we went to Valencia Island.

The reason we drove was because we took our dogs on holiday. Now, even though our dog is micro-chipped, I think it's silly that they have to go through so many treatments to stop them carrying rabies back from France.

Another special journey, well, we flew to Sardinia this summer. We travelled from Bristol airport to Olbia airport. The flight took about two hours – much quicker than driving and catching the boat to Ireland.

Andrew Reader, born 2000

What would be ideal – to have a home here, but to travel a lot

Roger: But having gone to college; there are people who come from Swindon, and so on, and they describe their schools, and home town, which seems massive – I much prefer where we live!

Rachel: I'd personally prefer to be in a bigger town because at least then I could just hop on a bus or underground and meet up with friends more easily – and there would be more places to go to.

Aspirations for the future? Well, next year I'm starting a PGCE in London, to go into teaching music in secondary schools. I'm going travelling this summer, to Thailand, to teach English. I chose not to do a gap year, but last summer I went to Morocco and travelled around Europe.

Henry: Generally, I have absolutely no idea what I'd like to do in the long-term. I chose music for university because it's something I know I'm good at. I don't have any strong desire to travel the world.

Roger: I want to do zoology and go into zoological research. I'm not sure which university I'll choose yet – I know a couple of possibilities but don't feel any urgency yet. I've always found animals fascinating – the way they behave and so on, and also I am hopeful to travel around a lot and see the world. Something along the lines of David Attenborough would be ideal – to have a home here but to travel a lot.

Henry: I like it 'up north' but I wouldn't want to live abroad and sacrifice my Englishness, and I think I'd eventually prefer to settle 'down south'.

Rachel: I've thought about living abroad but I don't think I could.

Howard: I think I'd probably like to go into something that involves sport; football and cricket in particular – I've been captain of my cricket team for four years running now.

Rachel, Henry, Roger and Howard Auster, born 1989, 1990, 1993 and 1995

Public transport

I never use it if I can possibly avoid it. As soon as I passed my test I made a vow that I would never use a bus again! It is so inconvenient having to plan your day around getting on a bus or a train or something. I get on really well with my parents and it suits me to live away a lot with my friends as well to fit in with my social life.

Henry Ravenhill, born 1985

Food Access
and Production

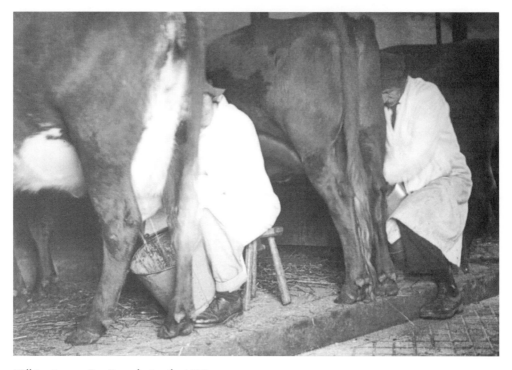

Milking time on Box Farm during the 1930s.

Can you remember how your parents got the food when you were little?

Did they have it delivered, grow their own produce or go to food shops regularly?

In a typical 1930s kitchen

Bread was made daily, staples like onions, potatoes, carrots and turnips were kept in the root cellar. There was usually a 'kitchen garden' and vegetables. Dairy was also brought daily, delivered from the local farm or local grocery store.

Box Farm 1930s-50s

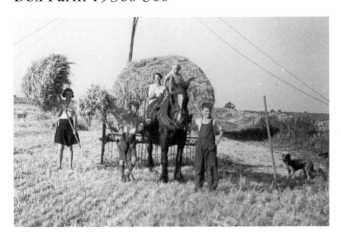 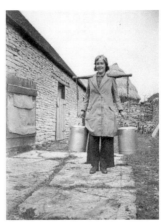

Left: Horse and hay cart during the harvest on Box Farm, 1950s.
Right: Milking yoke and pails, 1950s.

In the 1950s

Of course tea would be on hand, as well as baking staples. Cured meats and sausages would be either from the pig fattened in the pigsty in the back yard, or from a local butcher. People often kept their own chickens for Sunday dinner or daily eggs. There would be fish on Friday and porridge was a common breakfast food.

Keeping Pigs

Besides working 12 hours a day, father kept about 20 pigs. My job was to clean the pigs out every night when I came home from school, from the age of 10 onwards. Then I'd go along the fields with two sack bags, and I had to pick dandelions, cow parsley and clover and give the pigs a bag of this for their green stuff.

We ate the trotters and the tail, and made a stew with the backbone. When the head was cooked, all the meat would drop off and mother would make brawn by pressing it between two plates.

Norman Vick, born 1914

Preparing an animal for the pot

I have followed the animal from his birth to his appearance on the table; I have fed him and slayed him, I know the position of his various joints, and I have carved his meat. Now I'd like to celebrate his existence by eating him.

In earlier days a great many sheep were kept on the hills.
Corn and roots were planted in the fields. Instead of sheep,
the farmers now go in for beef and a great many horses and
ponies roam about on the Common.

Piped water and electricity came to the farms after the
1939-45 war. This brought many changes. Electric fences and
milking machines etc made life much easier after pumped water
and oil. Contractors do a lot on farms now like cutting and
baling hay. No butter or cheese making or bacon curing is done.
The interviewer found no silage. (Mrs. Franklin.)

When the Misses Baynes lived at Lammas they kept their own
dairy cows and supplied people in the village with lovely milk
at 1d a quart.

A number of owners have paid off their tithes. Cost is
20 years tithes.

Milk is now collected in churns for Cadburys of Frampton.

With mechanical ploughing came the need for wider gates
and all new gates are now 10ft wide.

T/T herds mean less cattle on the Common.

Mr.Jeffs made his own potatoe digger and collector.

WI Reminiscences,
1952.

In the 1960s...

Weekly, mum took a list to Walker's stores, (now Murrays estate agent), and it was delivered by bike; we had our milk delivered daily (Mr Lives from Blueboys Dairy), and we also grew vegetables, spinach etc.

Angie Ayling, born 1960s

Dad's down the allotment

For food, my Dad used to grow all our vegetables in our garden in Burleigh, and when we moved to Minchinhampton we also kept chickens at the top of our garden, for the eggs. Dad also tended an allotment close to where the scout hut is now, on Dr Brown's Road.

When we moved to Minchinhampton my Mum used to shop at the Co-op in West End, where we had a 'Divvy' number that gave us discounts on food. We also had Walker's Stores in the High Street and baker Halls and baker Dufty's. When I was

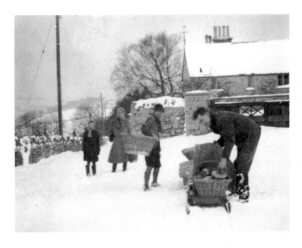

Delivering bread in Minchinhampton 1947.

young, Harmer Stores and Walker's Stores used to do home deliveries, taken by boys on bicycles, particularly to outlying homes in Box and Hyde.

John Bingle, born 1945

Modern Thinking

Are we seeing a big shift in the way that we think about the environment, food, nature, energy and capitalism – or is it all about feeling better about ourselves?

Government has recognised issues of food security and the role of home-food production in the future. Garden Organic chairman Tim Lang said 50 per cent of Second World War production was food grown in gardens – and this can happen again. Community, environment and carbon concern are the watchwords for the future of Minchinhampton.

From a humble packet of seeds

Gardening has been my passion and hobby since I was very young. I guess it's something I got from my mum; she used to love being out in the garden and we had a beautiful garden. My mum used to just let me toddle; she let me open packets of seeds and I'd try to plant them. Mum grew vegetables and my granddad, in particular, was very good at his champion leeks, and that spread throughout the whole family.

I also remember a horse and cart that delivered vegetables; it would stop in front of the houses. We could go outside and order from the man who came with them, I think it stopped when I was about eleven. We also had a mobile shop from the Co-op that brought deliveries; you could actually walk in and choose your food. We also had a large Co-op about 7-8mins walk from our home. They would have big slabs of butter and cheese; nothing was pre-packed. Nothing was wrapped in cellophane or a plastic

tray; it was just there, cut up and then wrapped up for you in greaseproof paper, which of course meant that shopping could take a lot longer.

Michelle Thomasson

Hard times

Our farm wasn't affected by foot and mouth; but actually, those farms that didn't have the foot and mouth were far worse off, because there wasn't the hefty compensation. Obviously, we didn't have the trauma of losing our animals – that would have absolutely destroyed us; but we had the terrible situation of having no income from cheese sales because there were no farmers markets.

We just couldn't get off the farm. Also, as our farm was on both sides of a main road we couldn't move our livestock from one side of the farm to the other. It was difficult getting food to our animals; they were eating hedges and we were having to eke the food out by feeding them half a dozen times a day.

TB (tuberculosis), on the other hand, is a completely different kettle of fish. The compensation, if your farm is affected, is pathetically small.

The money given to compensate for infected cows does not replace them. It's far below the market value and it doesn't take into account the loss of production; so if you lose an animal that has just calved, for instance, you lose a whole year's milk production and you've lost the animal. It is a complete nightmare, the scourge of the South West.

Melissa Ravenhill, born 1953

Minchinhampton Country Market

Of course, one of the biggest barriers that Minchinhampton faces, these days, like a lot of small market towns, is the issue of parking. The problem is that a lot of people just don't want to walk very far from their cars, and so building a large car park on, say, the Great Park, would not necessarily improve trade in the town. Of course, disabled people need easy access, and you can understand people who just want to quickly dash into M&B Stores for a pint of milk. Maybe they should think about having short stay parking bays – but who would police it?

We would also like to put a large sign up on the Cirencester Road to attract passing trade to our Thursday country market, but the Highways Authority and Town Council won't allow it.

I must admit, though, that I do like the peaceful nature of Minchinhampton, so in that respect I would not want to see too many changes being made for the sake of the car, and I certainly don't want to see more traffic coming through the town centre. Market days are busy enough as it is. It's a difficult balancing act to keep everyone happy.

Janet Payne, born 1950s

This year 2010

Mum takes me down to Sainsbury's down in Stroud each week, to fill a trolley with food, clothes and so on. I like to choose a salad from the help-yourself counter and we get packets of dried cranberries and nuts for pudding. She just uses a credit card to pay for it.

We go shopping in the car.

Jack Stubbs, born 2000

We buy locally and also from France

My raw materials I get locally as much as possible, so I get milk from across the road – the Woefuldane Organic Dairy. Our meat comes either from Taylor's butchers, just down the road, or Lucy Offord, the lady up at the farm shop on Tobacconist Road, and there's also a farmer in Slimbridge. I get fish from David Felce, who runs the fish market stall in Stroud. He used to sell his fish here once a week, under the Market House. I get vegetables from the man who delivers to the shop, actually – M&B Stores, and in the summer I drive round to local farm shops and get vegetables in season. I like to go to the place in Shurdington, near Cheltenham, the pick-your-own. The asparagus there is really nice, and I make my children go and pick raspberries and strawberries there. I have to bribe them with money because they do pick masses. I do grow a bit at home as well.

Well, in this pottery they make these special pots called cassoulles which is where the word calloullet comes from. So, we go and buy pots from him. They sell really well actually. And another thing we buy is soap. That's from an olive oil cooperative. So everyone who grows olives around there, in the South of France, even the smaller farmers, take their olives along to be pressed to make oil, and then make soap. We did sell olive oil but it didn't sell very well, but soap does, so we just kept going with that. I buy the olive oil for the restaurant, of course.

As far as our internet shop is concerned, and the amount that we sell compared to this shop, it's probably about half-and-half. On the internet nothing happens for ages, we'll forget to check it; then suddenly you get loads of orders all at once. Sometimes people come to eat here, they really enjoy the wine and decide to buy a bottle or even a case there and then.

Sophie Craddock, born 1960s

We never admitted to being bored to Mother

When I was young my mother kept goats, which we milked, and chickens for the eggs. We had a donkey that would carry wood in its panniers when we went collecting down on the slopes behind Amberley. We had about half an acre of vegetable patch as well, so there was always a lot for us to do when we got home from school. You never admitted to being bored to Mother, I can tell you, because you'd be out digging or weeding, milking the goat or cleaning out one of the pens.

As an adult, well, I had a water cooler business that I started in 1996, selling the big, plumbed in water coolers. It was in Nailsworth and was called the Water Warehouse. We ended up with about 25 staff. Ann here, she worked for me, but my co-director, Natasha, went off to have a baby. I decided to sell up, and we got a really good offer from another company. The money from that sale gave me the opportunity to buy this place and to put some investment into the business as well.

I've been here three years now, and the shop has been up and running since April of 2009. Before opening the shop, I had taken a year off to do some courses at Hartbury College – growing vegetable plants, soil improvement, and so on, basically to fill in the gaps of my knowledge.

Right from the beginning, I was keen to sell vegetable plants to people, because I knew from my own experience, when I was working full-time, and with a son as well, that I just couldn't get the seeds to work.

I'd be getting home from work, sorting out tea for my son, and with so many other commitments as well, I wouldn't necessarily have time to check on my seeds or seedlings, so they'd grow all leggy. That was my stumbling block on growing my own stuff; it was just too much. When you're out at work from 8 o'clock in the morning until 5 o'clock at night, in my case, I had dogs to walk, as well as cooking, cleaning and housework to do; I wanted to spend time with my family, and it just didn't give me time for anything else really. I mean, even in the summer the lawn would take me at least an hour and a half to do, and so any free time that I had was very precious.

I've been amazed at how popular these plants have been; I mean, last year I couldn't believe how popular the runner bean plants were. Someone said to me, 'Oh, they're too expensive', but I couldn't grow them fast enough – I must have sold at least 250 plants. Every time I grew some, I already had more ordered, and they grow so well in this soil.

The thing about last year was that we had an early spring, people got things started with seeds, I think we had a good April, but then we had a dodgy May and people's plants were keeling over, and that's when they came to me.

The meat and the eggs to go in the farm shop are all part of this. I basically wanted to find many different ways to make fifty quid, you know, not just put all of my eggs into one basket.

I've got the pigs for meat, of course, but they also clear the ground for the following growing season – they make great rotavators because, of course, they eat the roots of weed plants as well. This area here is pig rotavation that was done just before Christmas, and now we don't have to worry about the weeds getting caught up in the rotavating machinery itself, when we come to do it. Any waste veg goes back to the pigs. They don't eat any animal derivatives, although I have to say that they do have the occasional egg, which they really enjoy.

I try to use companion planting as much as possible because, as I eat the crop, I am very anti- spraying. So, if nature can help me to avoid the spraying then I'm all for it.

Lucy Offord, born 1965

Food access

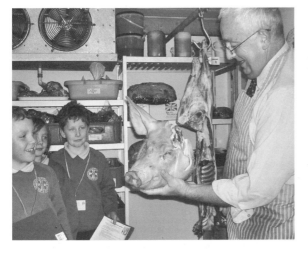

Behind the scenes of Taylor's, the butchers, October 2009.

Last cattle marking day on Minchinhampton Common, summer 2000.

Lucy Offord's Tobacconist Farm.

Energy and Fuel

A bunker full of fuel

When I was a child, in the 1960s, we had a coal boiler which heated a few downstairs radiators – none upstairs. We had to bring in coal from the coal bunker round the back and dad used to keep the fire stoked.

Angie Ayling, born 1960s

We had our coal delivered by a Mr Furley from Kingscourt, who drove a big truck for the Co-op. He would very often shovel the coal into the sacks and then carry the sacks round the back of Park Terrace, to our coal bunker.

John Bingle, born 1945

Heating

Up until the 1930s wood and coal were the main types of fuel in Minchinhampton. Cooking was done on an aga based in the kitchen and this heated water in a back boiler. There was town gas available to the wealthier houses but this was used mainly for lighting. Oil became more widespread for heating in the 1960s. The discoveries of oil in the North Sea meant that the gas coming through the pipes was now natural gas (methane). This fuelled the conversion of train power to diesel and also the availability of cheap to run cars.

Chris Stone and Sue Edgley Discuss Future Energy with the 'Time Detectives'

This discussion took place during one of the Community Scrapbook after-school workshops, October 2009.

Chris: So, we've been talking about our energy needs as a community; how many houses do you think there are in Minch?

Flo: About seventy five?

Sue: Ooh, there are a few more than that.

Andrew: Are there about a thousand?

Chris: Well, in the centre, that's the bit that we all probably walk around, a thousand is probably not far off; in the whole of Minchinhampton it's around two and a half thousand.

Phoenix: Wow, that's a lot of houses! How many people are there?

Chris: About three thousand.

Sue: Yes, and if you think of all the people in all of the houses, in each house they're using their washing machines and their lights and so on. How many light bulbs do you think there are in Minch?

Chris: Well, a typical house will have about twenty, I suspect, so if you times that by two and a half thousand, well, that's about fifty thousand light bulbs just in Minchinhampton.

Dan: That's a huge amount!

Sue: And, just think, every one of those is burning fossil fuels.

Flo: I've got a question written down here. It says, how big a wind turbine do you think we would need on Minchinhampton Common to generate enough power for Minchinhampton?

Chris: Well, we would probably need more than one, to serve the whole of Minchinhampton, and I suspect they'd need to be seventy metres or more, which is an awful lot.

Tabitha: Oh, like the one at Nympsfield?

Sue: Yes, what do you think of those? I think they look rather nice.

Maureen: Does our architect know the answer to that one?

Hannah: That's almost as big as far we run in a sprint race!

Flo: Another question; if we did want to put up a windmill on the Common, who would we need to ask?

Sue: So, who do you think; the people who own the Commons – The National Trust?

Kara: It is certainly windy enough for one, I would have thought.

Chris: Yes, did you know that there did used to be one at the end of Windmill Road, where Windmill Lodge is now. And do you know how many windmills there used to be

in England? At one time, of course, windmills were all the rage for providing the power to make flour and bread.

Phoenix: Were there about fifty thousand?

Chris: You're very close, there were about twenty five thousand.

Sue: Would every town have had one then? I suppose a lot of towns would have relied on water wheels, wouldn't they.

Maureen: Yes, of course, over a hundred years ago, around this area, it was the water wheels that allowed the woollen mills to become so successful.

Hannah: So what happens when the wind doesn't blow?

Maureen: Yes, good question, what can we fall back on when there's no wind power?

Chris: Well, this is why we need a variety of energy options and that's a big question indeed.

Maureen: Okay, so, moving on, how many of you have recently become Eco-Warriors in this school?

Dan: I have!

Andrew: And me!

Maureen: So what have you been doing so far?

Dan: Well, we might raise money to buy energy efficient light bulbs for all the classrooms.

Andrew: And we are going to do a survey, to look at ways to save energy.

Maureen: I know the school already does composting and each class grows its own vegetables ... Jack, what kind of things have you grown in your class?

Jack: Umm, we've grown potatoes, tomatoes, strawberries, carrots...

Andrew: Some classes have grown courgettes as well.

Tabitha: Oh yes, and some weird long stringy things...

Phoenix: Oh yes, runner beans, and lettuce as well.

Maureen: Do you recycle paper here as well?

Kara: Yes, we've got those big, special bags that we put our scrap paper in.

Maureen: Good, and has anyone heard of a hippo brick that you put in the toilet. Why do you think they might put a brick in the top of a toilet?

Flo: Doesn't it reduce the amount of water that you use when you flush it?

Maureen: Brilliant, yes it is, so that you're not wasting as much water.

Maureen: Okay, now let's look at these photos. This shows where Minchinhampton's power comes from. Does anybody know what this building is?

Hannah: Is it a factory?

Phoenix: Or a sewage works?

Maureen: No. It's actually a nuclear power station. Does anyone know where the nearest one is?

Sue: Severn Berkeley. It's very close, isn't it?

Maureen: And this photograph?

Phoenix: That's just an ordinary petrol station.

Andrew: And that's a gas flame.

Maureen: And this thing on the sea, what does that do?

Jack: Is it a boat?

Andrew: Is it something that goes across the channel?

Tabitha: A submarine?

Maureen: It actually gets power from the waves...

Chris: Yes, it's a wave turbine, so it goes up and down, not like a wind turbine that goes round and round.

Maureen: This is a huge power-line that can bring power all the way from the hydro electric plants in the mountains of Wales and Scotland.

Tabitha: I've got a question here. Why are people getting so worried about energy supply and global warming?

Kara: Like, everyone is killing the rainforests.

Maureen: Why is that such a bad thing?

Flo: Well, the rainforest produces...

Phoenix: Lots of rain...

Flo: It makes a lot of oxygen, and we need that to breathe.

Maureen: Yes, that's right and it also acts as a sink to help remove excess carbon dioxide from our atmosphere.

Dan: That picture is of the ice caps that are melting...

Phoenix: And are those factories making pollu... pollution?

Maureen: Brilliant, yes ... and this picture?

Andrew: It's a flood; we saw that on the motorway, last year, when we went past Tewksbury. There was a caravan floating.

Maureen: Yes, that's something that people think is being made worse by global warming. This picture here is a building in which you can actually produce energy from sewage.

Kara: Ugghh!

Sue: Ooh, why not? It's a natural process – why not harness, make use of, what we've got?

Jack: But that's disgusting!

Maureen: Well, in many ways, it's just like putting manure on your garden to help things to grow.

Sue: Yes. I mean, what's happening is, when you eat food, what comes out the other end is what we need to put back into the soil, to replenish what's been taken out when you grow things. It's sensible, but yes, it's just getting over an attitude that's hard, isn't it.

Maureen: Yes, even gas smells if you have a gas leak.

Kara: Oh, there are some solar panels, what do they do?

Tabitha: Oh, they collect energy from the sun.

Hannah: Oh, and a log fire – that looks nice.

Chris: Yes, and of course glass can be adapted to provide good insulation, particularly important if you have things like sky lights and extra big windows.

Tabitha: Oh, and that picture is somebody re-energising an electric car.

Maureen: Brilliant. Does anybody know what geothermal is?

Phoenix: No.

Maureen: Well, it's when you get heat from way down in the ground, another source of energy.

Flo: Yes, rainwater collection we do, into a water butt, to water our garden.

Maureen: Oh, and here's a sewage system where your toilet water and so on goes through your own reed bed to clean it.

Dan: Oh no, I wouldn't want that – too smelly!

Maureen: It's a shame they had to cancel your school trip to the water treatment works.

Maureen: Does anybody know who the man in the picture is?

Andrew: Yes, **David Drew**.

Flo: I shook hands with him!

Sue: Did you? He's a nice man.

Flo: Yes, he came for a meeting with our School Council a few weeks ago.

Maureen: So, who is he and what does he do?

Flo: He is a Stroud MP and so he kind of looks after us. You'd like me to read this quote from the slide?...

> 'My colleagues in Parliament always pull my leg asking if everyone, (in Stroud), is like me
> – vegetarian, teetotal, a mad, fanatical cyclist and someone who is always demanding drastic
> solutions to bear down on climate change and environmental degradation.
> I believe that there is a thirst for change here and that we must and should be taking the
> lead over environmental matters.'
>
> *Stroud News and Journal*, June 2009

Sue: Yes, so he's a great inspiration for all of us. Oh, and that picture – does anybody know where that picture was taken?

Phoenix: He looks like a poser...

Sue: Well, he is Dale Vince, another man that is trying to lead the way for renewable energy. He's the man that runs the company Ecotricity. Does anybody know what that is all about? No? Well, Ecotricity is a company based in Stroud, run by that man in the picture, who is posing; he is trying to make all the electricity that they produce, using wind turbines. So, people that sign up to Ecotricity, they are supporting a natural method of getting energy. So there we are.

Dan: Ooh, amazing. I like these cartoons of carbon footprints.

Hannah: And that slide says, 'How can we help at home?' Turn off the lights more?

Maureen: Yes, I'm sure you've all been told about that.

Dan: Stop cooking!

Phoenix: No, that's silly, but you could cook less, and eat more sandwiches and salads! Smoked salmon sandwiches.

Jack: Mmmm ... nice!

Sue: How about the making of the bread – that takes energy.

Kara: Let's shop locally, that helps to save energy.

Andrew: Yes, we walk down to our shops a lot.

Hannah: And I live almost next door to them.

Maureen: Now that we've been behind the scenes of some our shops, which one did you like best?

Flo: Oh, Sophie's, because she was so nice and her food was delicious.

Sue: Well, I think you are all Eco-warriors, and on behalf of Chris and myself, I'd like to thank you for being such lovely hosts.

Lighting

In the first half of the twentieth century, street lighting was from town gas (from burning coal), provided by the Stroud Gas Light and Coke Company. During the Second World War, there were difficulties in keeping up supplies of gas. Gas lighting continued until the 1950s when electricity came to the town.

I can remember the last lamp lighter, and he was called Percy Grange. Hampton used to be lit by gas lamps on a pilot. Percy Grange would come along with a long stick with a hook at the end. He'd put his hook in the chain hanging from the lamp, pull it down and the light would come on.

Concerns for the future

In this day and age there are increasing concerns about the dwindling supplies of resources such as oil and gas for energy, and everyone is becoming worried about climate change. This is why we are all being asked to try and save energy as much as possible.

Communications and Latest Technologies

The advent of electricity

Radios were around as early as the 1920s, but as soon as electricity became widely available in the 1950s other household appliances started to appear in Minchinhampton. Televisions became more affordable in the 1960s.

'I remember us always having a telephone, a radio and car when I was a child. We first had a TV in 1966 when my dad broke his leg. We did not have a computer at home until 2008!'

Angie Ayling, born 1960s

Katie has a chat with the Time Detectives

I remember when we got our first telephone, and I remember the number was 3888. My mum was so not used to having a telephone, she used to say, 'Hello, this is three eight double eight', but one day somebody phoned up and asked if it was three double eight eight and my mum said 'No', and put the phone down!
 Thinking about world events around the 1960s; there is one event that really stands out in my mind – it was July 1969. Do you know what happened then? I'll give you a clue – look up...

Tabitha: Was it something to do with the stars?

Not exactly.

Andrew: Or when the sun goes red – an eclipse?

No.

Tabitha: Or when somebody learned to read the stars for directions?

No, that was a few years before – but a good guess.

Maureen: Up, out of the atmosphere, keep going, keep going...

Andrew: Oh, is it when Apollo 11 landed on the moon?

Yes, excellent! I was six years old at the time, and we didn't have a television. We walked round to a friend's house and we watched it on her black and white set – her black and white television. We used to listen to the radio a lot, but we didn't actually call it a radio, but a wireless.

And when I was five, in 1968, it was announced on the radio that an American politician called Robert Kennedy had been shot dead by somebody. It was somebody who didn't know him but it was an assassination. They didn't agree with his politics.

Five years earlier his brother J.F. Kennedy had also been shot. Does anybody know who he was?

Phoenix: Was he an American president?

Yes, he was – well done! And I can remember crying because I thought it so horrible that anybody would shoot somebody else.

Maureen: I remember when I was that age, at about the same time as you, Katie; if there was a momentous occasion like that, we would all sit in the school hall – this is the whole school, and watch the event on television. Because so many people didn't have televisions then, even the parents would be invited in.

Andrew: Lucky!

Katie Jarvis, born 1960s

Future Communications

- Can you remember when your family first acquired a telephone, radio, television or computer?
- How do you think people will be travelling and communicating with each other in 20 years time?

A Future Sustainable Community

As far as the future is concerned, I'd like to see people growing their own vegetables more, and to enjoy the therapy and rewards of being a bit more self 'supportive'. There certainly seems to be a hunger for that sort of thing. You can make good friends, and it is very satisfying going up to the allotment and sharing views, tips and produce with other people who 'grow their own'.

John Bingle

The Transition Initiatives

How did I become involved with Transition Minch? Sue Edgley and Mike Sheldon had two boards up at the Goodwill evening in 2008. They were explaining the meaning of the Transition Movement. I already knew about transition because of my interests and concerns about sustainability, and the problems with the way in which we have our food distributed. I thought, well, I'm studying this at university now, and I'm hearing the concerns from influential people who are very active in their academic fields, in research and from government. As I am learning about this I feel I have to find a way to practically apply it; it would be wrong not to try and do something. Then, a few weeks after chatting with Sue and Michael, they asked me if I'd like to join the steering group, to guide how transition might work for Minchinhampton. The Transition Town initiative has been taking off in so many towns. It was started off in Ireland by Rob Hopkins and it is spreading out to all sorts of communities, not just in England, but around the world as well.

People are interested because they realise it's a very practical, down-to-earth way to try to solve a problem by our own behaviour, really. It is a very positive way of bringing communities and environment together, which, of course, is the most important thing, and to share in our achievements as well. Strong and fair communities, this is what I would like to see in the future, for the sake of our children.

Michelle Thomasson

What do we really want from our family and community?

My concerns and intrigues for the future; I think we need to really stop and think about what we want to achieve in response to climate change. This is the reason why I

welcomed the opportunity from Sue Edgley and Michael Sheldon, when they invited me to join the steering group of their new group, Transition Minch. I felt that I could offer my technical and scientific expertise in the field of architecture, buildings and energy, for example.

For me, the Transition Movement means becoming more aware of what is going on in the world. We read about things in the press, see the news on TV, but sometimes it's good to get a different perspective on things. It's about seeing a different view which may make us think a bit more deeply about our own role in planning for, and influencing our future.

In Minchinhampton it is about making people aware of the issues. We design posters and provide information around Minchinhampton. We gave a big presentation a few weeks ago to help people think about how they can save energy and so cut their gas and electric bills.

Let me give you an example; in this room, you have two big heaters throwing out lots of heat. We have to think to ourselves, do we really need the room to be this warm? Do all of the lights need to be on, because there is a lot of light coming in from outside – that sort of thing. I can give you information about a new type of light bulb that uses less energy but provides more light. It is about being aware of how latest technologies can help us to save energy.

We try to do so many things but without adding them up properly first. We need to resist launching into lots of initiatives simply because somebody says they are a good idea or if there is funding available for it. It is good to learn from others but it's also important to stop and think how it can truly benefit you as an individual or family, in terms of your property and lifestyle. This is the key and this is where architects can help.

This is the kind of thing we are able to advise people on, of course, when we are building their houses, offices, schools and so on. It's part of our job as architects. This is what it is all about; thinking outside the box and hopefully, that will inspire other people to do the same thing as well.

Chris Stone

Is Minchinhampton an Eco-friendly School?

As Eco-warriors are we trying to do a lot of things?

- Do we have eco-monitors who close the doors to keep the heat in, turn off the lights and computers to save electricity?
- Do we have compost bins and water butts to produce compost and to save water?
- Do we grow our own vegetables in our classrooms and vegetable patch which we give to the kitchen?
- Do we recycle paper and use scrap paper so we don't destroy more trees?
- Have we also put hippo bricks in the toilets which save water?

If we want an exceptional school,
LET'S BE ECO-FRIENDLY!

Do you think your parents would sign up to a car share scheme?

How would it work around their lives, living in a rural community?

'Our core purpose is to take, and inspire others to take, collaborative actions that strengthen our local community and respond positively to the challenges of climate change and declining energy supplies.'

The Transition Minch mission statement

How times are changing

Rees: I'm sure many people have said this, but before the television set was around people didn't worry so much. Now you have these sensationalised stories on the news about something happening to a child, and parents think, well, that could happen here. Well, honest to goodness this town is a lot safer than other places. People say, even newcomers, 'Oh, it is really lovely up here, we have just the right number of shops to make a community and make it work, we don't have to go to a supermarket for the majority of essentials, and the quality of the things is just as good, if not better than, anything you could get elsewhere'.

Peta: But going back to how things have changed for children and their families, well, of course a lot more mums work now. Well, my mum gave up nursing to have a family, but then she set up 'Party Plan', which was something that fitted very well around the children. She was one of the very first Tupperware ladies running parties around Stroud. Because she was working it meant that she could afford to pay a cleaner twice a week. She had Mrs Stone who walked over from Hampton Green. This was when we were living in Beacon Park. It felt like an up and coming society, where more wealth was being brought into the family. If you take Beacon Park, actually there are probably about half of those people still living there. So, you've got the Gotts, the Baxters, and Joyce and Terry Thomas lived opposite us down there. What seems to be happening is that the offspring seem to move away and then come back when it's time to have children, because the school is so good and so on. Many of my school friends have come back. Tammy has moved back, and then there's Jerry who lodged with me in London. My friend Tim Brown, he lived in Oxford. I could probably pull together fifteen old primary school friends who are still living in Minchinhampton. There was also John Pring who set up the Bowbridge veterinary surgery.

Many people started with the smaller houses on Beacon Park and then moved into bigger houses, but stayed around Minchinhampton. Doug Gunn – his parents lived opposite us in Ricardo Road. He moved away down to Devon way but then moved into Minchinhampton and now lives in a beautiful big house on Well Hill.

As far as my own adult life is concerned; I lived in London for eighteen years, then I came back. My husband and I used to visit Mother and Pa three or four times a year, and then we had a cottage in Stroud, so we would come down every other weekend.

When my marriage broke up, because Minchinhampton is such a beautiful part of the world, the countryside is fantastic, mother was still living here. It is easy access to communications to go to London, north, south east or west, really, and I had still got lots of friends here. London was such a rat race; everything is much slower here. It's a better quality of life; the air is better.

What I also liked about moving back into Minchinhampton was the new friends that I made, many of whom had moved into the area at about the same time.

How times have changed, and many changes too!

Peta Bunbury and Rees Mills

Thoughts on our future

- Where does the energy for Minchinhampton come from and where could it come from in the future?
- Why are people getting worried about energy supply and global warming?
- When might we start to see any changes in the way things are done, or will the problem be solved behind the scenes for us?
- How can we help?

Birth of the Business Regeneration Working Party

The changes that I've seen ever since we moved here; well, once I'd actually retired, I noticed the community fracture and then come back together again. That's all happened in the last eighteen months.

I don't consider Minchinhampton to be a dormitory town. The road where I live, for instance, has changed from being a road of holiday cottages and elderly people, to being a road of young families with children. I suppose, historically, change always happens like this, but I think people who live in the surrounding area already do see Minchinhampton as a place they would like to move to, so there is a lot of demand for houses from out of town.

The school here is excellent; it's got strong church links. Minchinhampton has got everything that a lot of people want, and as houses have become empty, twenty years ago those houses may have become holiday cottages. Now they have tended to be re-developed and become family homes, which is superb.

The Business Regeneration Working Party came about in August 2008. That was a spin off from the Post Office Working Party. We lost our old post office in Tetbury Street

because of an argument between the then chairman of the Parish Council and the post master. This over-simplifies the situation but a lot of difficult things were said and this is what caused a lot of splits in the community. I got involved purely as a resident wanting to do something about these awful arguments that were going on.

Well, eventually we managed to get the new post office up and running in the High Street; then the new chairman of the Parish Council asked me if I would like to take on business regeneration, because a lot of the businesses had lost out tremendously due to the loss of the old post office for three months.

We had also lost Lloyds bank in recent years as well, so people went elsewhere for their pensions and other financial arrangements. This meant that they didn't use the cafes, the butchers and all the other shops that they were used to going to on a regular basis.

The businesses wrote to the Parish Council asking what it was going to do to help their situation, so that was how it all started.

The pledge scheme came about at this time, encouraging residents to spend at least two pounds a week in Minchinhampton. I wouldn't say it has been hugely successful, in all honesty. Several hundred people did sign up, but a lot of these people were already spending more than two pounds a week in Minchinhampton's shops anyway; but what it did achieve was that it put Minchinhampton on the map. It started the process of getting us recognized as a Cotswold town. Before this, we weren't on anybody's website – they always seemed to miss us out. I mean, tourists do bring trade; and even if some people might want to keep this town quiet and secret, there is always a fine balancing act going on between tourists and the interests of the locals, as there is in any town. If we want the two empty shops to become shops rather than offices or domestic premises then we have to accept that tourism is part and parcel of it.

The regeneration group, at the moment, is working on a twofold approach; a new website and also a leaflet about Minchinhampton, so it's not just The Commons but the town as well. The website will be something like www.minchinhamptoninfo.org. The local authorities are putting Minchinhampton on their www.cotswolds.com, so they're making more of an effort, and if the leaflet is eventually produced then that will go into all the tourist information offices around this area, within a fifteen mile radius. At this stage I left the group as I had joined the Parish Council and felt that the group should not be overloaded with Councillors; also, I had got involved in other projects.

Moving on to Transition Minch (see photograph above), well, Sue Edgley was the first person to get in touch with me. She approached me because of my involvement in the Regeneration Group. We met up, had a coffee and I suggested various people that I thought might help her organisation get off the ground. At that time I wasn't prepared to be involved with Transition Minch because I was still very busy with the Regeneration Group. But eventually, I felt that they probably could cope without me. Minchinhampton, currently, is reasonably successful, despite whatever various shopkeepers might say. We have had lots of free publicity that has come from the pledge scheme; the heavy snow last winter, 2008 and 2009, has helped people to appreciate the local service that shopkeepers provide (food etc.), and the Calor Village of the Year Area Award in 2009 was also a great boost. We can't complain.

My reason for joining the steering group of Transition Minch was that I have been very concerned, in my role as a Parish Councillor, that the Minchinhampton Parish

Council was not taking the Transition Movement and Transition Minch seriously. I felt that the Transition Movement deserved better than that, and so when Nick Hurst suggested that Transition Minch try to get somebody elected onto the Parish Council, I thought, well, there is someone already on the Parish Council who supports its ideals.

I think there are an awful lot of people who need to go through a process of a change of attitude, to start to feel more responsibility for their own community, which at the moment they don't. It's a sign of the times, I'm afraid – a mobile population who perhaps stay a few years, then move on. The attitude is that other people can do that.

So, going back to Transition Minch, I thought maybe I could help to represent the group's interests in the community, within the Parish Council, so that there isn't an us-and-them situation where one group just dismisses the views of the other. I don't necessarily want to get involved in great international debates, but I'd like to play my part.

My concerns and hopes for the future; well, I think we need to take more responsibility for our own use of energy, and to become more interested in a sustainable lifestyle. Let's use supermarkets by all means, but we also need to value what's here in Minchinhampton. Let's encourage local businesses and local support systems.

I'm very encouraged by the seeing up of a wood gathering group in collaboration with Richard Evans, our National Trust warden, to manage our local woodlands. We have a wood burning stove in our house, and we have wood delivered from the tree felling at Cirencester Park.

It would be lovely to source it closer to home, but elderly people like my husband and I cannot do the wood gathering ourselves.

It is the same with the shredding of garden waste. We have got a car but we can't lift big amounts, but that would again be a lovely mulch for our garden.

What we need now is more publicity for the groups that are being set up locally, under the heading of encouraging more sustainable lifestyles, and reclaiming useful skills from the past.

We also have new beginnings with our new vicar, our new headmaster, and lots of new things happening, but it is still an uphill battle to get people to change their ways, and to think about how we are shaping the world for our children's and our grand-children's generations.

This is their future and unless we do something about it now, you know, it's no use having our gas guzzling cars when our planet's resources are struggling to keep up.

Linda Nicholls

Give us a sign

Things I would like changed or improved for small businesses in Minchinhampton; well, I think one thing that would be very good, which they do in our village in France, would be a sign post on the main road, pointing down into Minchinhampton, with the names of all the local businesses. Our village in France, it's called Kisac and it's very similar to Minchinhampton in that it is off the main road, but you have this sign naming the restaurant, the boulangerie, the hairdressers, and so on. They do have it for

industrial estates in this country. It's very useful when you're travelling, because you then know that it's worth going down into the town. I think at the top of Butt Street, the sign wouldn't even have to give the names of the businesses, but just say restaurants, tea shops, chemist shop, local shop, and so on. So many of my customers have said that in the past they have driven past Minchinhampton a massive amount of times and they didn't even know that there was anything here. I mean, whether the Business Regeneration Group has looked into this, I'm not sure, but it would be good.

Sophie Craddock, Sophie's Restaurant

Some people just don't like change

Changes to Minchinhampton that I've noticed over the years? Well, we try to look after our elderly neighbours, but I've noticed that when they die, and their houses are sold, young families have tended to move in, and then you have the problem of two cars per house.

Apart from this, the business side of the community has gone up and down over the years. At the moment I would say it is on quite a high, the businesses in Minchinhampton are generally doing okay.

Car parking is a problem, of course, but we still manage to get customers and I'm always amazed at how people do manage to get to us.

I think there have been some good ideas about improving the layout of the town – to help the parking situation, but they are not listened to. People just don't like change, and that's it really. I can understand people not wanting more cars coming into the town.

For instance, when Cambridge Way was originally built, it was meant to go right down through to the Market Square, but now they've built a bungalow for disabled adults in its path, so there's no question of opening up that access route. The residents appreciate the peaceful nature of that road.

Another example is during the school run, where parents are asked to use a one-way system, so driving down Cambridge Way, through the school grounds and out again at the bottom. It just isn't adopted by some parents and so they can cause gridlock when they're trying to drive up against the flow of traffic.

Any concerns that I have for Minchinhampton? I think the parking issue certainly has to be addressed, not just for the sake of businesses but for the sake of the people who live here as well. You have to say, well, we're not going to get rid of cars, they do bring trade, and so often we're crawling up and down these hills following an empty bus. I mean, it's all very well pouring all this money into providing public transport, but we live in the age of the individual, and we don't play that game anymore, not really. People don't want to stand around waiting for buses, and there may be a better community answer that can be given to meet the transport needs of those without cars. Minchinhampton is a pretty cohesive community – a community of neighbourliness.

It works so well for so many people and you can see why people don't want to change it. I would never be one for wholesale change, but there are things that need to change. I say again that we need evolution not revolution.

Mick Wright

Parking's always a problem

Do I have any concerns for the future of Minchinhampton? Well, parking's always a problem, and it's surprising the number of people who don't come here because of the parking. We have at least 52 cars coming into Minchinhampton every day to work and they have to find public parking spaces. A lot more than that go out, but it's still a big problem.

Crime in Minchinhampton – well, a few years back we had this steel door fitted, and the shutters and the alarm; it used to be just glass. Before that was put in we'd had three or four break-ins. It was just opportunists, really, taking advantage of an easy glass door to break through. It's just a sign of the times, and you have to try and alleviate it, by doing something about it, don't you.

The old chemists was broken into several times. There was one night when almost all the shops were broken into, oh, years ago now. They were just going round to see what they could get. Nobody's broken into the men's club – fort knocks that is!

Fred Price

The world is based on oil

I first learnt about the Transition Movement in 2007 when I went to a talk in Stroud by a quite famous man called Richard Heinburg, who is a world expert on peak oil. Peak oil means that when we've removed half of the oil that's available in the world's oil wells, and once we've reached that halfway point, we have potentially quite a big problem, because the world is based on oil. Everything we do, you know, transport, food production and packaging, manufacturing and so on, all depends on oil, and so the need to prepare has become a big issue.

Well, my husband and I were quite shocked by this talk and we thought, well, we need to help get everybody ready, because it's quite possible it might happen in just a few years time, where oil shortages might impact on our way of life.

For me the Transition initiative is about preparing for the twin problems of peak oil and climate change, so that we try to reduce our dependency on oil, and also so that we reduce our carbon footprint.

Back in Minchinhampton, the first thing that we did when we first started out, about a year ago, was to have some awareness raising events, to try to get people to understand what the problem is, and then to see whether there is a solution and what we can do about it.

So what we did first was, we hired the church, which was pretty unheard of in Minch, you know the Holy Trinity Church, and we had a talk by Rob Hopkins, who is one of the people who started up the Transition initiative, trying to get towns across the country to prepare for the possible eventuality of what we have just been talking about, about oil dependency and everything, and how we can reduce that.

Then we had a film in February last year about the ways in which Cuba had to adapt to having their oil suddenly cut when the Soviet Union split up and became Russia and all the different countries. All of a sudden ordinary people had to grow their own food, not just in the countryside but in the middle of cities as well. So that film attracted quite a lot of people.

Next we had an event on a Saturday afternoon, in April, to talk about how we might grow more food in Minchinhampton, to encourage people to think about growing more food in their own gardens, to get more allotments and maybe even get a community supported farm that we could all be involved with in some way, and since then we have been growing from strength to strength.

I feel that my background as a trained doctor and psychiatrist, and my present occupation as a therapist, helps my role in Transition Minch because I am able to listen to people, and also to become more interested, open and aware of what is going on in the wider world. I like to put things into practice, take action and do something, because otherwise one can get depressed, fed up, anxious or even frightened if you feel there's nothing you can do personally.

Sue Edgley

Let's try to make do with a little bit less

When it comes to the Transition Minch, well, if people want to know what it really means and what I believe it really stands for, it is all about making do and appreciating what's on your doorstep. It is about being realistic and thinking about the healthy way to do things, both for ourselves and our environment. It's not about, 'Oh, I can only eat this muesli if it's organic', so that it has to be flown all the way from Peru, say. That's not the answer to our world problems. What we should be doing is making do with a little bit less and making the effort to provide a little bit more – if that makes sense.

So, if we make a point of buying British manufactured goods, British manufacturing goes up and provides us with more jobs; if we make a point of buying what's on our doorstep, whether from the local convenience store, farm shop or farmer's market, then this, again, puts money back into the community – it really does work.

When people ask me if the food is organic, well, I'm sorry, but my chickens get their food from Kemble, which is a lot closer than many suppliers of organic chicken feed. (It would just be too much for me to try and produce all of the feed for my animals as well). How can organic corn that's had to be shipped all the way from Scotland, with all the carbon footprint that that entails, be better than buying locally?

We also have to think twice about why we invest huge amounts of energy to grow exotic vegetables in greenhouses all year round, when we should simply be happy to buy local vegetables in season, and enjoy the extra special treat of having British strawberries in the summer, when they're available as nature intended. We really do have to look at all the different angles and think about the implications of what we are doing, and make an informed decision, not just be carried away by emotion.

Another thing, organic is meant to be about growth and development, protecting the environment, and so on; this is a very good thing in itself, but the organic label is not always a guarantee of quality. I mean, they did an independent check on organic salad washes fairly recently, didn't they; the Soil Association had rubber stamped an organic lettuce, and when independent checks were done on it they found that it had chlorine in it. Well, that doesn't exactly inspire you with much confidence, does it?

So, all the organic vegetables that had been sold by that supplier, in the supermarket, may have been grown under organic conditions, but they hadn't been through a safe and organic wash. The 'organic' label doesn't cover animal health and welfare and farm husbandry either, so there is no strict criteria on how you treat your organic animals. For instance, you can have 3,000 crowded chickens that are half starved, and your pigs can be badly treated; they can still be called organic because they are being fed organic feed. You can't call them free range but you can call them organic.

I mean, animal welfare should be a priority on everybody's list, right to the end of an animal's life. This is why I 'do' my chickens here. They don't have to be starved for 24 hours before slaughter, to make it easy for a machine to get out the bowels and the crop on a conveyor belt. I can take my time on each bird. I haven't got the overheads that the big farms have, and my animals are two minutes from pen to death – they don't have to endure stressful journeys in a big truck, starved for 24 hours, and then thrown into an electrified bath. I know which I would choose. I can kill my own chickens because I know they've had a good life and they're having a much better end than factory farmed chickens.

I think people are generally much more interested in where their food is coming from, and they're interested in the food chain. I had a lady come in the other day and we got talking about the leg of lamb that she'd bought from me previously. She said it was the first time she'd made a shepherd's pie with leftovers. Her family said it was the best shepherd's pie they'd ever had. That hadn't been her kind of thing before that point, but she thought, well, I've bought a decent leg of lamb – I'm not going to waste it. I think people are surprised at how satisfying it is to be that bit more creative with their cooking; the make do and mend culture that's coming to life at the moment, I think it's brilliant. It's the same with clothing as well isn't it, make do and mend, nip it in at the waist, lengthen the straps, there are so many things you can do.

My hopes for the future of Minchinhampton – well, when I was young, Minchinhampton was just so vibrant, it had so much going on, and then in the '80s it just hit a massive nose-dive, particularly by the '90s when my son was born. It was like rats leaving a sinking ship. Everybody increasingly had their own cars so they could just flock to the supermarket, and forget the local trade that was suffering. Everybody could get their social life elsewhere. There were so many more shops and pubs then.

I couldn't believe it the other day, when I was with some friends who were down from London. We went for a walk around the Lammas tunnels and West End and we happened to be passing the old West End Stores, you know the one that doesn't seem to open, but the display mysteriously changes every now and then. Well, my friend's partner noticed people inside, moving the display around. I think he was planning on going into Trumpet antiques, and he asked them if they were selling stuff; he actually bought an old sign from in there – bizarre really, when you think the shop has been closed for years and years.

I do love the little sunk footpath with the mini tunnels that go under the Lammas gardens. The rich owners didn't want the public footpath going through their gardens. There's another one up on the Common next to Beaudesert as well – sort of subterranean tunnels, and quite magical.

My plans for the farm now – I don't think we'll put many more polytunnels in, but I'd like to get the nursery up and off the ground, and I'd like to extend the range of plants if things are successful. I'd like people to come here, because what we're doing here is unusual. I mean, we've got the farm shop, and the animals that children in particular like to come and visit.

People do seem to be making the effort to shop in the village as well as their supermarket shop. I have a lot of respect for the likes of John Williams on the Parish Council who volunteer their time freely to help make this a successful community. We all need to pull together and volunteer our time otherwise we're just a bunch of individuals doing our own thing and with no central core, which is what is happening in the larger towns and cities these days, where you've got no sense of community. We are lucky in this area in that there are people who don't expect to be paid. I think it has a lot to do with the church. I must admit that as I've got older I've kind of softened to it really, because I can see how important it's function is in the community, and how it's good for us to stick together. I mean, when you're young, of course you want to spread your wings a bit and do your own thing.

We've got a nice vicar now in Chris Collingwood, and his wife. He invited me to the newcomers' party, after I've been here for 43 years, but I was pleased to accept.

But I'd just like my business here to be successful, to generate enough income so that my partner can give up his job. We'd like to build a small campsite in the bottom field, only for about twenty pitches, just for the summer from April to September, and they could buy stuff from the farm shop. There aren't enough campsites in the area anyway. Some people are also looking for somewhere to park up their motor homes as well, so that's another thing.

As far as the shop is concerned, my cows go out on the Common; I have a few grazing rights that come with the deeds of the house. We do poultry, which is plucked and dressed on site here; we've got pigs that are raised here for pork. I buy lamb from Thomas Jackson up at Frampton Mansell. I know his animals are well cared for; they are the Vendine breed. They've been raised with the ewe. I don't think we pose a threat to Taylor's the butchers, because what we do is so small in comparison.

I stock Chris and Becky's Five Valleys cordials; I've got gardeners stuff that you wouldn't necessarily be able to buy from a garden centre, and other gifts.

I've got Jonathan Ionides trout pate, which has proved very popular. He and his wife, Cherry, are lovely characters – real individuals. I understand he is a vital member of the local wood-gathering group; he says he has a chainsaw but he's not sure if he's officially allowed to use it because he hasn't done the course.

Over Christmas I was snowed in, but I sold over 200 Christmas trees and all of my turkeys quickly sold out last year. There's a lady in Bussage who makes chutneys for the farmers market down in the Shambles in Stroud; she's kind of my age, trying to do something off her own back, and so she puts advertising cards out for me and I sell her stuff here free of charge, for the time being anyway. This spring has been so late getting started so it's early days for the plant selling business again.

Lucy Offord

An interview with Ian Crawley, Transition Minch, 10 March 2010

How long have you lived in Minchinhampton and how does it compare to other places that you have lived?

Five years. I appreciate the time that people are willing to spend time to just stand and chat, and the beauty of the old town; the commons and the surrounding wooded valleys keeps a smile on my face and a spring in my step.

What is your occupation?

I spent 35 years providing public services to local people. Now I am a volunteer helping improve the area for the benefit of all.

When did you first learn about the Transition Movement?

From seeing the flyer for the Rob Hopkins presentation in the parish church and being intrigued by his focus on community; and the need to build our collective resilience in the face of peak oil and climate change. Both of which, along with the killing of our oceans, present the most fundamental challenges to the continuation of our current way of life. Politicians will not publicly acknowledge this because there are no votes in it!

How would you personally describe the Transition Movement and how is this being introduced in Minchinhampton?

Bottom up, grassroots, community based are all ways of describing people getting their act together themselves, rather than waiting for others, or being dependent on the state. That is not to say that government at all levels does not have important roles. Much can only be sorted out and delivered in this way.

I was active in the LA 21 movement in the 1970s, where we sought to, 'think globally and act locally'. That petered out because the oil crisis proved short-lived, and governments and the media were more interested in the message that resources are limitless.

The Transition Movement's unique selling proposition is based on whole village, whole town and whole community. There is a recognition that we are all in this together, and that the only important geographical identity is with the people we meet and the services we can access close to our homes. The movement also recognizes that individuals in those very communities have the skills, experience and resourcefulness needed to establish the resilience necessary to face the future with confidence. Bearing in mind the size of our population, and the way in which resource intensive systems are embedded in our daily lives (particularly when it comes to food distribution), technological advances will remain crucial.

The internal combustion engine may well be fuelled by hydrogen. The scale and pace of change necessary will, however, require fundamental changes in our daily lives. The Transition Movement is alive to this, and is working now to address it.

What we, as a group, have been doing, is building awareness of the need for us to change, through films, presentations and discussions. We have also organised small-scale practical projects, such as introducing composting into the parish churchyard and

setting up a wood-gathering group in collaboration with the National Trust, to gather wood around the slopes of Minchinhampton Common.

How do you feel your occupation and background helps you with your role in the Transition Minch steering group?

I was trained as a town planner. Rare amongst the professions, that training develops the planners' ability to see the wood and each individual tree simultaneously. To focus on specific issues, problems and opportunities whilst keeping hold of the whole picture. Why else have national and local governments placed on the planning system the responsibility of regulating the use and development of land to deliver sustainable development and tackle climate-change? In the Transition Movement we need to focus on small-scale practical initiatives that contribute to the big picture, whilst keeping that big picture in sight and mind.

What kind of initiatives would you say have been the most successful since Transition Minch started over a year ago?

My view is that the only change that endures is that which people believe in. If people have chosen to change their behaviour, it is because they decided to. They may well have been influenced by a change in the law, or in their economic circumstances, or because of what they have heard or seen.

The twin priorities for TM are to raise awareness about the need for change, and to help people to find ways in which they can change what they do, and how they do it. We try to demonstrate, through practical initiatives, the action that people can take themselves.

The wood gathering project goes to the heart of what TM is all about. This group is working with the National Trust in the woodlands around the town; the aim being to work, with the help of sufficient volunteers, to manage the woodland appropriately so that fallen trees do not rot where they fall. At the same time, we realise that the needs of local wildlife must also be respected. At the moment, many residents with wood-burning stoves are buying in wood, cut many miles away, and transported into the area. For a few hours of voluntary labour each month, working alongside a NT employee, the volunteers are able to take the wood they need at no cost.

Are there any things that you feel could be improved in the way that Minchinhampton is planning for its future?

We need to find land that can be used by residents to grow their own food, individually and collectively, to have community fruit and nut orchards, and to introduce a community composting scheme. Energy costs are an increasing proportion of everyone's household budget. We need to retrofit existing homes to minimise energy costs and CO_2 emissions. The footprint of Minchinhampton on the UK is far larger than its size as a place on the map. That is because it imports all its energy and most of its food, goods and services, and exports most of its waste. That is not sustainable. We need to keep finding ways of reducing that footprint.

Do you have any other comments that you'd like to add?

The big freeze in February 2009, and again in January 2010, reminded people of how dependent we are on easy and safe access in and out of the town, travelling to supermarkets elsewhere in the Stroud Valleys. Many people could not drive for four or five days. This was a shock for those whose lifestyle is based on a daily shop, because they choose to buy all of their daily needs. We very quickly forget the way in which our beliefs and way of life was challenged, and revert to our comfort zone of the familiar. We have to think, and then act, on a future where such problems will reoccur more frequently, be it through climate change or peak oil.

A few words from Michael Sheldon

How long have you lived in Minchinhampton and how does it compare to other places that you have lived?

Just over 4 years. I have lived in many different places and every place is unique. It is just that Minchinhampton is very unique!

What is your occupation?

Self-Employed Gardener (Four Candles Garden Services). I have various clients in and around Minchinhampton whose gardens I help to maintain.

When did you first learn about the Transition Movement?

About 3 years ago when my wife, Sue, and I went to hear Richard Heinberg give a talk for Transition Stroud. Richard Heinberg is one of the world authorities on the subject of Peak Oil. We were both very affected by the implications of what he was saying and I suppose that is what lead us to get the ball rolling for Transition Minch.

How would you personally describe the Transition Movement and how is this being introduced in Minchinhampton?

It is very much a 'grass roots' movement, involving ordinary people, from all walks of life, coming together to look at the challenges we face, today and in the future. In particular, the challenges of climate change and resource depletion.

It's about community and empowering people, providing a catalyst and opportunities to become more aware of what's happening in the world, to actually do something practical to make a difference.

In Minchinhampton, we have tried to have at least one event every month on a range of different issues. We have also worked with and involved other groups and established organisations. So, for example, we have worked with Holy Trinity Church and The Baptist Church on composting and building compost bins, and we've gone into

school to hold a Recycling Event and talk with the young Eco-Warriors, and of course, working with the Parish Council with the 10:10 Campaign. It's about making use of the networks that we already have here.

How do you feel your occupation and background helps you with your role in the Transition Minch steering group?

Working with the earth, plants, working outside and being very aware of the seasons, gives me a great appreciation for the miracle of life that is right in front of us, right beneath our feet. It's a gift. And yet we often do not realise the many ways in which we are trashing this gift every day, in so many ways. So this is the great incentive to want to make a difference, even if it is only a very small difference in the scheme of things, and to at least try to raise people's awareness.

What kind of initiatives would you say have been the most successful since Transition Minch started over a year ago?

The first TM event, the Talk that Rob Hopkins gave, was very successful and inspiring, and got us off to a flying start. I also loved showing the film, *The Power of Community* about how Cuba survived its own oil crisis, which we showed several times in various locations in Minchinhampton. It is such an inspiring film. Even though Cuba is different from the UK in so many ways, it really gets across the message of the power we have as a community when we come together to face challenges, and how a simpler, yet healthier, richer, more fulfilling life can be had without having to destroy the Earth and other people.

Are there any things that you feel could be improved in the way that Minchinhampton is planning for its future? What new ideas and initiatives are currently being pursued at Transition Minch?

I would love to see more local food initiatives, especially organic initiatives. We are very fortunate to now have an organic dairy and a local farm shop in Minch now, but it would be great to have something like a community growing scheme, such as Community Supported Agriculture (CSA) and some organic allotments. However, it is so difficult to get the necessary interest and engagement when the cards are stacked so heavily in favour of mass-produced, pesticide and chemicalised, and 'convenient' food. People are unaware of the hidden costs, they just want 'cheap on the purse', and fail to see the hidden costs to health and community.

So, there is a great need to build awareness of the issues, and maybe showing films such as *Food, Inc.* and holding other food initiatives will help.

Do you have any other comments that you'd like to add?

Just to say that Transition is about acting and doing something practical, about getting on with it, and about having fun along the way. It's a lot more than just talk.

Transition Minch group photo, 2009. Top: Linda Nicholls, Chris Stone, Michael Sheldon, Ian Crawley. Bottom: Sue Edgley, Michelle Thomasson, Maureen Reader.

Some of the Comments coming out of the Planning for Real Weekend 27/28 March 2009

How do you see the future of Minchinhampton?

'I would like to see more jobs being created actually in Minchinhampton, perhaps by the Parish Council providing small grants to encourage young people to set up their own business here'.

Rebecca Herd

'I would like to see a huge reduction in the amount of dog mess on the common. We also need safe cycling routes to and from the village for those who live just outside, but use Minchinhampton as their main source of produce.'

George and Fran Thomas

'I would like to see the school, doctor's surgery and library with solar panels on top. I also think that no new build/conversion should be allowed without the latest energy saving technology incorporated.'

Tom Kemp

References

The Last Days of Steam in Gloucestershire by Ben Ashworth, 1986

Minchinhampton Life and Times by the Minchinhampton Local History Group, October 2000

Stroud and Rail – In Old Photographs collected by S. J. Gardiner and L. C. Padin, 1987

Minchinhampton and Nailsworth Voices by Katie Jarvis, 2001

Gloucestershire at Work by Stephen Mills, 1997

'Travelling Along The Trail', 12th Nailsworth Festival, 1995

Gloucestershire at Work by Stephen Mills

Where the Cow is King by J. V. Smith

Gloucestershire Within Living Memory by the Gloucestershire Federation of Women's Institutes

Minchinhampton Jubilee Magazine 1952 – 1977

Minchinhampton Life and Times Part 2: Places, School, Organisations and People

Minchinhampton Life and Times Part 4: Reminiscences

Mrs Beeton's Cookery and Household Management, 1960

Time Detectives – Great Grandma's Schooldays by Jean Morgan

Stroud News and Journal – News clippings 2009

Minchinhampton with Box Parish Magazine, 2008 & 2009

Tom Long's Post, 2009-08-22

Minchinhampton Country Fayre Magazine, 2001

Also available from Amberley Publishing

Minchinhampton &
Amberley Through Time

Howard Beard

ISBN: 978-1-84868-047-0

Price: £12.99